Landscapes
in Watercolour

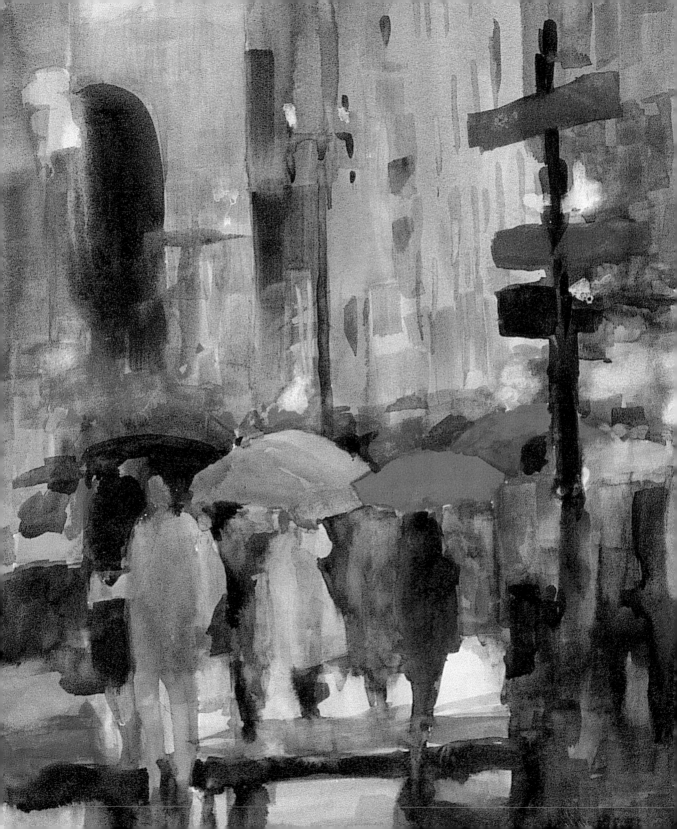

Landscapes in Watercolour

Theodora Philcox

Creative Painting

**Sterling Publishing Co., Inc.
New York**

**AVA Publishing SA
Switzerland**

Published by AVA Publishing SA
rue du Bugnon 7
CH-1299 Crans-Près-Céligny
Switzerland
Tel: +41 78 600 5109
Email: enquiries@avabooks.ch

Distributed by Thames and Hudson (ex-North America)
181a High Holborn
London WCIV 7QX
United Kingdom
Tel: +44 20 7845 5000
Fax: +44 20 7845 5050
Email: sales@thameshudson.co.uk
www. thamesandhudson.com

Distributed by Sterling Publishing Co., Inc.
in USA
387 Park Avenue South
New York, NY 10016-8810
Tel: +1 212 532 7160
Fax: +1 212 213 2495
www.sterlingpub.com

in Canada
Sterling Publishing
c/o Canadian Manda Group
One Atlantic Avenue
Suite 105, Toronto
Ontario M6K 3E7

English Language Support Office
AVA Publishing (UK) Ltd,
Tel: +44 1903 204 455
Email: enquiries@avabooks.co.uk

Copyright © AVA Publishing SA 2002

ISBN 2-88479-004-7

10 9 8 7 6 5 4 3 2 1

Design by Sally Chapman-Walker
Creative Director and co-ordination: Kate Stephens

Production and separations by
AVA Book Production Pte. Ltd., Singapore
Tel: +65 6334 8173
Fax: +65 6334 0752
Email: production@avabooks.com.sg

Detail opposite:
'Union Square' by Sally Cataldo

contents

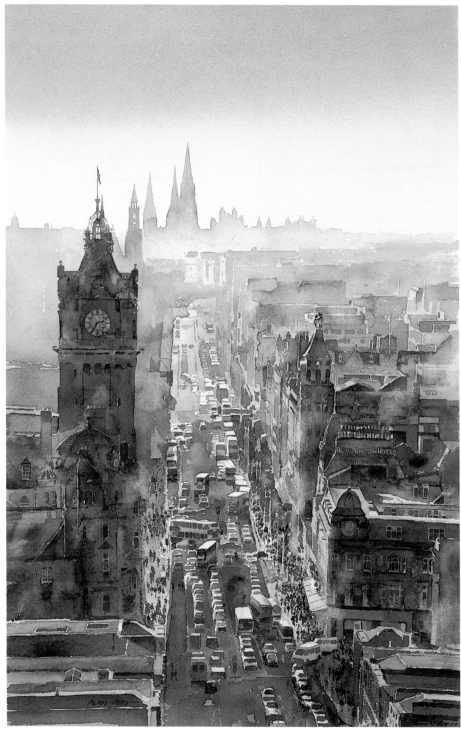

Edinburgh is a city brimming with history and impressive architecture. Over a number of years Alan Reed has worked to capture its spirit in a variety of conditions. Here, carefully thought out washes build up his impression of Princes Street, seen during the hustle and bustle of a winter's afternoon.

Princes Street, Edinburgh
Alan Reed

Watercolour and landscape have a natural and exciting affinity. Like no other medium, it has the capacity to capture the subtle nuances of the atmosphere that can transform even the most ordinary view into something truly magical. The most popular of all painting media, watercolour is also perfect for taking out on location. A small paint box, brush, paper and bottle of water are all that one needs. However, as all novices know, this apparent simplicity is deceptive. Paintings need to be carefully planned, with colour built up steadily through transparent and translucent washes, laid dark over light. White highlights are created by leaving areas of the paper unpainted, and once applied, pigment can be difficult to remove, change, or move around. If one tries, the prized luminosity that makes this medium unique can be lost. And yet its thrilling ability to yield results from the strikingly vibrant to the quietly subtle, make it difficult to resist.

As to landscape, it offers a virtually unlimited resource for the artist. Even the simplest small corner of land will have a thousand different faces as the seasons pass over it. There is nothing quite like the experience of working with the elements, directly from nature. Fleeting light and the vagaries of the weather combine to augment the challenge. However good a photograph, it can never compare to the personal story told by an artist's vision. The focus, the selection, the personal associations and memories that can be embraced in a single image ensure that a landscape is somehow always significant, whatever the standard of the artist.

In this book, more than twenty leading artists from across the globe share their personal experience of painting landscapes in watercolour, from the dusty streets of Rajasthan to quiet British inland waterways. Through inspiring examples of their work, and under the generic headings; 'Seeing', 'Thinking', and 'Acting', the artists explain their vision and particular methods of creating images that vary from the traditional to the experimental, together exploring the full potential of the medium. Large reproductions of each painting are supported by details, diagrams, or colour analyses, depending on the specific intent of the individual artist. Wherever possible, the painters talk the reader through their work, providing intimate insight into their motivations, inspirations, and techniques.

For aspiring artists, the wide variety of approaches and styles featured in this book create a sensual and stimulating visual feast that will help them discover their own unique painterly voice.

cézanne Nature is always the same, and yet its appearance is always changing. It is our business as artists to convey the thrill of nature's permanence along with the elements and the appearance of all its changes. Painting must give us the flavour of nature's eternity.

A variegated wash can
often produce a more
lively sky than a flat or
graded one, and allows
the artists to introduce
colours from elsewhere
in the painting to create a
more unified composition.

landscapes rural

Details from
'San Gimignano',
Alan Reed.
Paintings of rural
landscapes can
sometimes lack focus.
The most picturesque
scenes often don't make
the best paintings. Think
carefully about why you
want to paint a scene,
how you want to
interpret it, and what it
is you want to
communicate.

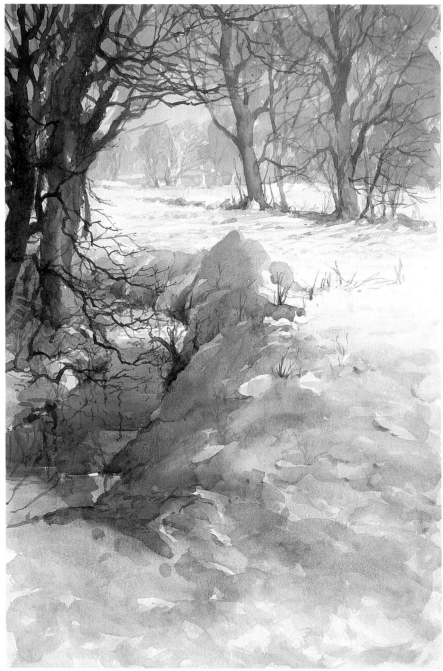

Snow provides a wonderful challenge to the artist. Faced with a blanket of white, what colours should you use, and how much texture should be introduced? For Alwyn Crawshaw, the key is often knowing how much paper not to paint at all!

Snow
Watercolour on paper

"

Snow

I have always had a fascination with painting snow, especially in watercolour. Perhaps it's **the challenge of how much unpainted paper I can leave to represent snow.** Or the freedom of brush strokes suggesting the subtle contours of thick foreground snow? Or is it the fact that all trees in the painting are winter trees, and I do love painting winter trees? Perhaps it's the very nature of the subject that draws me to it, with childhood memories of sledging and snowballing and just enjoying the snow.

Painting a snow landscape outdoors isn't the best environment, although I have done it on many occasions, with varying results from good to bad paintings and numb fingers. But this experience is invaluable for when you work indoors and most of my snow paintings are done this way. Naturally you have to use your memory and imagination indoors, and that's another challenge. I can't resist telling you this – by absolute coincidence, as I write this sitting in my studio in Norfolk, **it has started to snow very heavily, and my artistic adrenalin is now flowing faster than ever!** What timing!

In the main painting there was quite a lot of paint work done to represent the snow, but this is not always the case. In 'Winter Wonderland', which I painted from my imagination, I only used one wash for the sky, which I ran into the snow in the background to add mystery. The rest of the snow is white paper. I love this way of painting snow and it can create some very exciting snow landscapes. **The one ingredient for painting snow in this simple way is a big brush and plenty of confidence**, and that comes with practice.

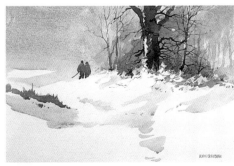

Winter Wonderland
Watercolour on paper

Alwyn Crawshaw is one of the best-known artists working in the UK today. Through more than twenty highly successful books, eight television series, and six teaching videos, he has made a significant impact on the amateur artists' scene around the world. A public library survey showed that one of Alwyn's books is taken out of a library in the UK every two minutes! Furthermore, through worldwide distribution of his television series, his influence extends as far afield as Bahrain, Japan, Singapore, Zimbabwe, Turkey, Norway, Australia and the USA.

Born in Mirfield, Yorkshire, Alwyn studied at Hastings School of Art. He is a Fellow of the Royal Society of Arts, and a member of The Society of Equestrian Artists, The British Watercolour Society, President of the National Acrylic Painters Association, Founder President of the Society of Amateur Artists, and an Honorary Member of the United Society of Artists. He regularly contributes to Leisure Painter magazine, and runs many popular painting holidays and courses. He is listed in the current edition of Who's Who in Art.

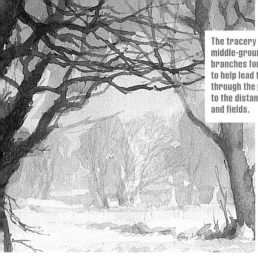

The tracery of the middle-ground tree branches form an arch to help lead the eye through the painting to the distant trees and fields.

I got the inspiration for this painting when I was wandering around our small paddock. There was just a sprinkling of snow on the ground. Naturally I knew this spot intimately, but I saw it differently that day. It inspired me, so I sketched it. It always amazes me how we can see the same things differently, when we see them in different circumstances. I have always told students, and myself – **when you see something that inspires you, paint it, it may never look the same again.**

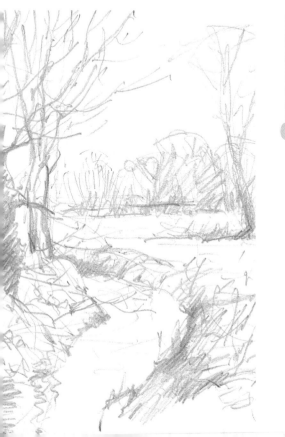

The painting was worked from the pencil sketch but was changed in places as I created the new composition. I felt that the portrait shape was more powerful and added more interest to the painting. *I made the distant fields bigger to give space and distance, and made the tracery of the left-handed tree branches form an arch to help lead through the painting to the distant trees and field. The shadow side of the bank gave strength and interest to the snow, and led the eye through the arch in a very natural way. I was almost tempted to put something into the arch – a person, an animal, or even a bird – but I decided not to disturb the wintry stillness that the painting created.*

I used one of my favourite papers, Bockingford watercolour paper, 250lb. Not. It takes washes beautifully and is ideal for lifting out either with a brush or a paper tissue. The colours were my normal palette: Crimson Alizarine, Yellow Ochre, French Ultramarine, Hooker's Green Dark, Cadmium Yellow Pale, Cerulean and Cadmium Red. I used a no.10 and no.12 round sable brush, with a rigger for the small trees and branches.

> Remember when you are painting snow, your greatest asset is the white paper. Look after it; don't waste it. The more you lose the less 'clean' snow you will have in your painting.
>
> Finally, don't be afraid to paint your snow shadow areas dark, this will contrast with the lighter areas and especially the white paper, giving dimension and light to the painting.

Crawshaw's normal palette:
Crimson Alizarine
Yellow Ochre
French Ultramarine
Hooker's Green Dark
Cadmium Yellow Pale
Cerulean
Cadmium Red

acting

I painted the sky and distant fields with a very pale wash at first, then the distant trees. This gave me a tonal point to work from. The middle distance and close-up trees, and the water were worked next. This set the scene and left the exciting part; the subject of the painting – the snow. I painted the snow with many large and small washes. **Into the original wet wash, I dropped different colours in the larger areas in the foreground and shadows; Yellow Ochre, Crimson Alizarine, and Cerulean.** *These colours blended together to help make the snow look 'transparent' and lively.*

Colours for livening up the snow:
Yellow Ochre
Crimson Alizarine
Cerulean

LIFTING COLOUR OUT WITH A PAPER TISSUE

Textures and soft highlights can be achieved very simply by lifting colour out using a clean brush, damp sponge or paper tissue. These absorb the colour whilst it is still wet, revealing the white or the paper, or leaving a gentle tint. The technique is particularly useful when creating soft clouds in a landscape.

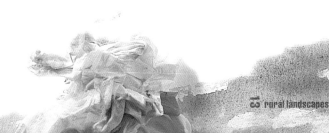

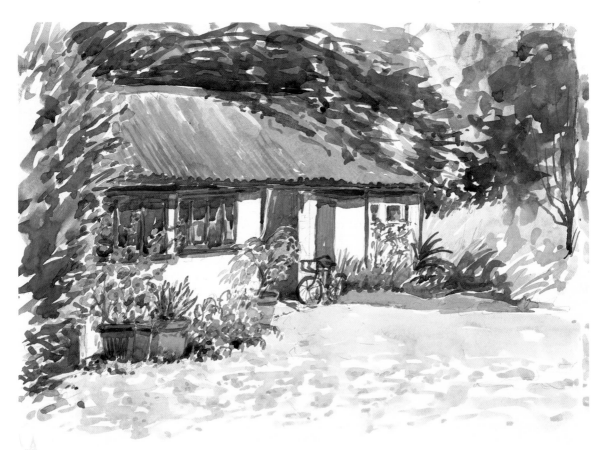

The Stable
Watercolour on paper

"

The Stable
I love painting outside. If the weather and time would allow, I would paint outside most of the time. **The elements, the freedom, the fight against time, the excitement, all make painting outside such a challenge,** *and of course, you learn so much from nature, which helps when you paint indoors.*

Naturally painting in the elements can help or handicap you. Sometimes I do a gem because I have to hurry as the light is going, or the rain is coming, and I can't overwork or 'fiddle' and spoil it. But the unfortunate can happen; rain and strong winds can stop you in mid-flight. Nevertheless, that is the joy of painting outside!

seeing

When I painted the stable I was lucky. It was a beautiful sunny day. I was inspired by the sun shining on the roof, the dark trees framing it, the flowers, the sun-drenched ground, and most important, the old trade bike leaning against the building. **The composition was already there. I am a great believer in natural composition**. If a scene inspires me, the natural composition plays a big part in that inspiration. Because of this, I paint it as it is. I am not one for moving mountains and lamp-posts out of the way!

thinking

I worked on cartridge paper for this painting. **I love the way cartridge paper accepts the paint; it runs freely** and you can control it using many watercolour techniques. Another bonus is that it's inexpensive! I always use artists' colours, working with a limited palette that includes Crimson Alizarine, Cadmium Red, French Ultramarine, Cerulean, Yellow Ochre, Cadmium Yellow Pale, and Hooker's Green Dark. I mapped out the highlights and shadows, recognising that for this image the shadows are very important. Without them it would not give the impression of a sunlit day.

acting

I painted the soft background colours first, then the roof, windows and pots. It was drying quickly, so this helped me to paint without breaks. I used fresh clean colours to get the bright sunny feeling. I put the shadows in using French Ultramarine, Crimson Alizarine, and a touch of Yellow Ochre. These colours make excellent transparent shadows. The lighter shadows were highly diluted, whilst in the darker areas I used much less water and more pigment. I painted in the foreground last, as I wasn't sure how much unpainted paper I wanted to leave. Don't cover all the white paper until the last minute if you are unsure of how much you will need. **I decided not to put shadows on the foreground as I liked the sun-bleached look**.

June Crawshaw started her artistic career mainly as a potter, but then began to concentrate on painting. She married Alwyn Crawshaw in 1957 with whom she teaches on their residential courses. She writes regularly for Leisure Painter magazine and, in addition to featuring in five of Alwyn's books, she has written some of her own. She has also been featured in three of Alwyn's television series. She works in watercolour, acrylic and oil, and exhibits throughout the UK. In 1987 she was made a member of The Society of Women Artists, and the following year, a member of The British Watercolour Society. In the late nineties she became a member of The National Acrylic Painters Association and was elected an honorary member of the United Society of Artists. Like her husband, she is also listed in the current edition of Who's Who in Art.

The play of light in the shade of the majestic Banyan tree, and the glare of tropical sun over the vivid colours of bustling village life, create a fascinating subject, visually and in actuality.

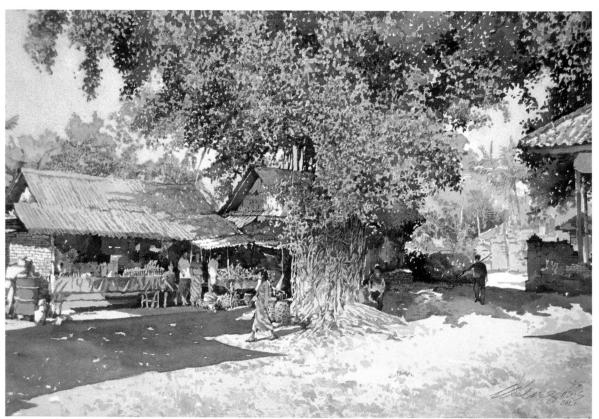

The Banyan Tree
Watercolour on paper

"

The Banyan Tree

A Banyan tree typically dominates the entrance to most villages on the Indonesian island of Bali. **Here, in Ubud, the fruit seller and the Balinese coffee shop beside the tree offered an array of activities everyday.** *I was staying in a little inn behind this tree, and was separated from this busy scene by the archway of the inn. I had tried to paint the scene many times before, but each time, I had engagements in the other parts of the island, so the idea was shelved. However, during one of the trips, when I had a chance to stay in this village, I finally settled down to paint this scene.*

Ong Kim Seng was born in Singapore and has been a full-time artist since 1985. He has won five awards from the American Watercolour Society, and became the first Asian outside the USA to be awarded AWS membership.

In 1991, Ong Kim Seng was awarded the Cultural Medallion for Visual Arts by the Ministry of Information and the Arts, Singapore, and he became a Dolphin Fellow in 2000.

He has been President of the Singapore Watercolour Society since 1991 and his Society is affiliated to the World Watercolour Society. He is also a Life Fellow of the National University of Singapore Centre of the Arts, Art Advisor to the National Arts Council, and a Member of the Arts Committee for the Singapore Broadcasting Authority.

His collectors include Queen Elizabeth II, Premier Zhu Rongji, People's Republic of China, and Kofi Annan, Secretary-General of the United Nations, among numerous others.

A Windy Day
Watercolour on paper

Positano, Italy
Watercolour on paper

I loved the quality of shade given by this gigantic tree and the buzz of the activities that took place in this area. It can be very uncomfortable painting in tropical heat, so it is important to work from a shady spot. This also reduces the amount of glare reflected from the white of the paper, which can be very hard on the eyes. **The Banyan tree was my point of interest, and together with the shops and people, it forms a 'V' composition.** *To balance the painting I added a shadow of a building to the left, which is not in the painting.*

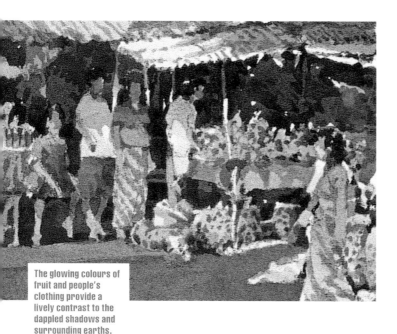

The glowing colours of fruit and people's clothing provide a lively contrast to the dappled shadows and surrounding earths.

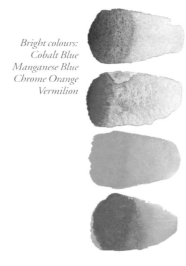

Bright colours:
Cobalt Blue
Manganese Blue
Chrome Orange
Vermilion

Before painting, I always make a detailed sketch. This helps me to focus on the main subject matter, yet not forget the smaller details. **I also closely study the tonal values of the objects before beginning to add colour.** *Wanting to create a textural effect for the tree and the buildings, I worked on Arches' 850gms rough paper. I love working with earth colours and these were important for this particular composition. However,* **with the variety of people and the colourful fruits sold at the stalls, I also needed bright colours** *such as Cobalt Blue, Manganese Blue, Chrome Orange and Vermilion.*

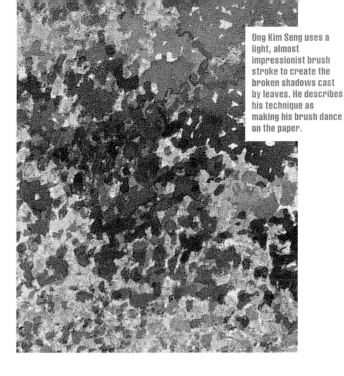

Ong Kim Seng uses a light, almost impressionist brush stroke to create the broken shadows cast by leaves. He describes his technique as making his brush dance on the paper.

acting

I used a glazing method here, **taking pains over the leaves of this majestic tree**. I applied light washes for the trees at the back so that the main subject would be the focus. I used a variety of greens for the trees, and earth colours mixed from Burnt Sienna, Raw Sienna, French Ultramarine, and Chrome Orange for the houses. I like to use a light touch with my brushes. This is very appropriate for painting the broken shadows cast by the leaves. **I describe my technique as making my brush dance on the paper**.

Earth colours are important to this particular painting. They provide the natural and harmonic foundation, allowing the brighter colours of the man-made elements to stand out in contrast.

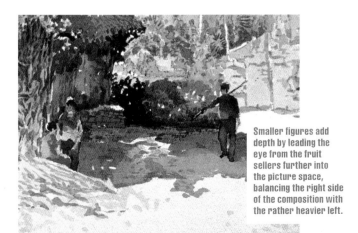

Smaller figures add depth by leading the eye from the fruit sellers further into the picture space, balancing the right side of the composition with the rather heavier left.

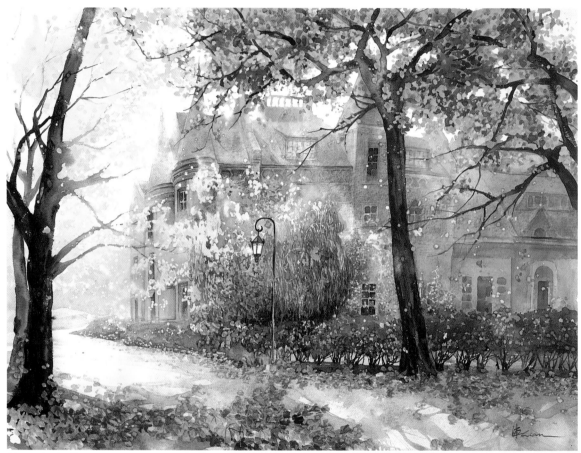

New England Fall
Watercolour on paper

The vivid colours of the New England Fall make an indelible impression on all who see them. Captivated by their beauty, Lian Zhen was compelled to record them.

New England Fall

When I arrived in Cambridge, Massachusetts in the fall of 1993 for graduate school, I was amazed and impressed by the colours of the trees, changing from green to yellow, orange, red, dark red and finally brown. **Walking under the trees I felt I was embraced by a colourful, warm and harmonic world** *that I had never experienced before. One morning I visited a college campus and saw this magnificent scene: a red brick building surrounded by the trees toned by soft lighting. I smelt the fresh air, touched the morning dew and listened to the songs of the birds. It was a peaceful moment, and I was eager to express this in my painting. In fact, after seeing the New England Fall, my paintings have been full of vivid colours.*

Lian Zhen began to take an interest in art at the age of ten, but became a physician in Canton Province, China. He is self-taught, and learned Chinese painting technique whilst still in China. He emigrated to the USA where he focused on watercolour painting, combining it with traditional Chinese techniques. 1992 saw him receive his Bachelor of Arts degree from the University of California, and four years later, he achieved a Master of Architecture degree from the Massachusetts Institute of Technology.

His work is held in a variety of corporate and international private collections, and he conducts teaching workshops across America as well as in China.

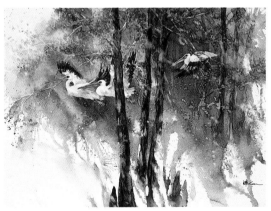

Swamp Rain
Watercolour on paper

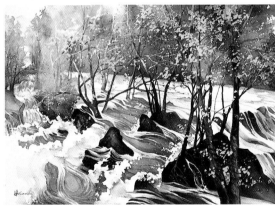

Merced River
Watercolour on paper

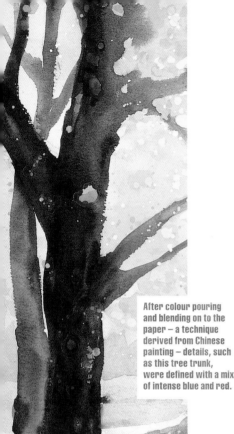

I took several photographs from different angles. None of them yielded a composition that expressed my feeling towards the scene. There was a great difference between the views in the photographs and nature itself. The former lacked life. **I therefore chose the view of the building from one photograph, trees from another, and backlighting from my imagination, to construct the composition.** Painting is not to illustrate or render what I see, but create what I want to see. **A great landscape painting allows viewers to walk into the scene, hear the voice of nature, and apply their imaginations.**

After colour pouring and blending on to the paper – a technique derived from Chinese painting – details, such as this tree trunk, were defined with a mix of intense blue and red.

I used a technique called 'colour pouring and blending', which uses the three primary colours to paint this landscape. The technique is derived from the 'ink pouring' method created about 1500 years ago in Chinese painting. I selected Arches' 140lb. cold-press watercolour paper and taped it to a board with parcel tape. **After sketching the outlines of trees and the building with a pencil, I used masking fluid to mask out the sky and the light-coloured leaves.** To prepare the colour for pouring and blending, I put the pigments into three small dishes, separately, and diluted them with water.

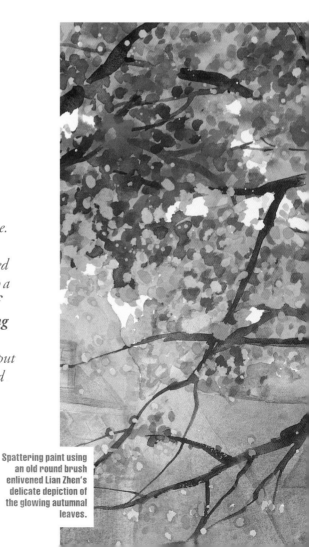

Spattering paint using an old round brush enlivened Lian Zhen's delicate depiction of the glowing autumnal leaves.

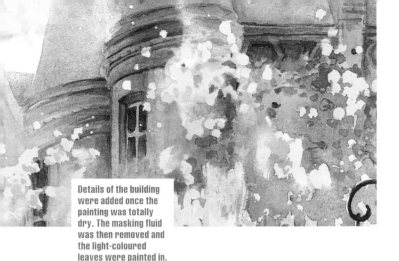

Details of the building were added once the painting was totally dry. The masking fluid was then removed and the light-coloured leaves were painted in.

1 Masking fluid is applied to the initial sketch, before the paper is lightly sprayed with water to dampen it. Fluid red, yellow and blue paint is then poured on to the paper, and encouraged to run and blend by tilting the board, blowing the paint, and using a flat brush.

2 Detail is applied in intense blue and red, and by lifting out colour with a moist round brush. Shadows are defined using a light blue and red. Masking fluid is removed using masking tape.

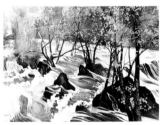

3 Final detail is added and the overall colour balance is harmonised.

acting

*When the masking fluid was dry, I poured the yellow colour liquid on the painting, starting from the upper left-hand corner. Then I poured the red on the tree leaves area and the blue in the middle and at the bottom. **I sprayed more water on the painting to direct the colour liquids flowing diagonally down to the lower right corner**. This created the light beam effect, as well as graceful colour blending. When the painting was about 70% dry, I painted the tree trunk and branches with intense blue and red. I also painted the trees and shrubs. When it was about 90% dry, I painted the shadows on the path with light blue and a little red. After the painting was totally dry, I painted the detail of the building. The masking fluid could be removed and I painted in the light-coloured leaves.*

To prepare colours for colour pouring, place about 6ml. of water into a small dish, then add pigment to achieve the desired intensity, depending on the size of the painting and individual preference. Use a small brush to stir and blend the colours. Lian Zhen tends to use just the three primary colours to keep it simple, but at the same time allows him to create an exciting and full range of blended colours.

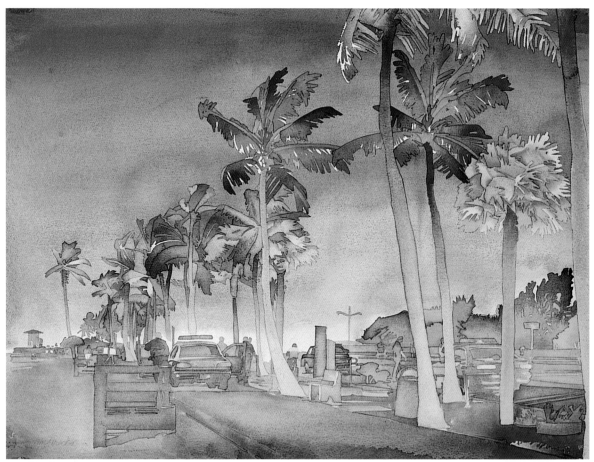

Windbreakers
Watercolour on paper

Lines of huge coconut palms define the coastline of Florida, rising like beautiful and imposing guardians against the potentially powerful elements.

pissarro Paint generously and unhesitatingly, for it is best not to lose the first impression. Don't be timid in front of nature: one must be bold, at the risk of being deceived and making mistakes. One must have only one master – nature; she is the one always to be consulted.

Windbreakers

I grew up in Florida where I developed a sensitivity for tropical imagery and its subsequent metaphor for other locales. This particular view of Southern Florida is from Lake Worth. The Floridians plant huge coconut palms along the beach. These majestic palms frame the coastline and act as sentinels for the warm ocean breezes. **They are at once strong and resilient; fragile and accommodating***. They tend to sway and mesmerise.*

Carol Carter

Working in St Louis, Carol Carter paints sumptuous large-scale watercolours and acrylics that quite literally glow. Working on a range of subjects that include landscapes, foliage, and her exquisite swimmers series, she has exhibited extensively throughout America. Her work is represented in many public and private art collections, including those of SAFECO, Blue Cross/Blue Shield, Boatmen's National Bank, Citicorp, Leonard Slatkin, Price University, and Utah State University. She has been featured in a variety of publications, including the St Louis Post Dispatch, the Kansas City Star, American Artist, and New Art Examiner.

In 1994 she received a MAA-NEA Fellowship in Painting and Works on Paper, and in 1997 she was commissioned by Laumeier Sculpture Park to create a painting to commemorate the Tenth Anniversary of the Laumeier Contemporary Art Fair.

Unnatural Habitat
Watercolour on paper

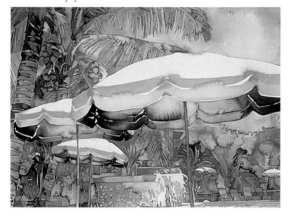

Unnatural Habitat

This watercolour landscape features the play of light on the umbrellas found beside a pool. In addition to natural landscapes, I am also intrigued with man-made, artificial ones. This particular landscape is in the Virgin Islands. **What compelled me to paint were the mushroom-shaped umbrellas contrasted with the lusciousness of the water, pool, and foliage***. The umbrellas are placed in the foreground and are the largest shapes. The smaller background shapes further enhance their grand scale.* **The rhythm and sequence of these umbrellas lead the viewer into the painting***. I used a very limited palette, with the Cobalt Turquoise and Burnt Sienna creating the predominant grey colour. The Cadmium Orange is contrasted with the Winsor Violet. The grey background highlights the purity of the orange and violet. Painting from background to foreground is important in this painting.*

Cold Comfort

Although this watercolour is of a specific place in Florida, it appears generic enough to mirror a variety of coastlines everywhere. **It's the 'beauty in the ordinary' that I like to capture**. The dynamic vertical nature of the palms seemed to contrast sharply with the horizon, or implied horizon, of the beach. **The architectural elements and small hints of human activity also contributed to the scale of the palms**. This composition highlights the rhythm and verticality of the palms giving them presence and a grand scale.

The scale of the huge palms is articulated through the inclusion of figures and architectural features.

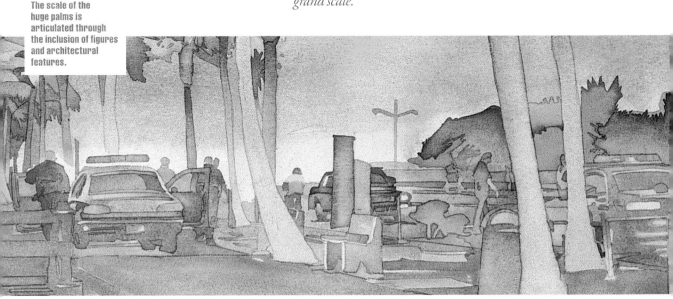

Carol Carter's 'tight' palette:
Indian Yellow
French Ultramarine
Burnt Sienna
Prussian Blue

thinking

When I first begin a watercolour I do a pencil sketch on the paper establishing all the points of interest. I use Arches' 300lb. cold-pressed paper. This offers a smoother surface and heavier weight. I try to 'see' the painting in my 'mind's eye', before I put paint to paper. I planned the painting around isolating and featuring the palms as the focus and centre of interest. I tend to use just a few pigments on my palette, to focus attention on the beauty of the washes and colour. **A tighter palette offers the painter a chance to be most creative with colour combinations**. Basically I use a warm colour and a cool colour to build and develop greys. Then I use a complementary pigment to draw attention. Here I used Indian Yellow, French Ultramarine, Burnt Sienna, and Prussian Blue.

I work flat, **which allows the watercolour to accumulate, flow, and puddle**, and I use lots of clear water – about ten containers at a time. The background sky was initially painted using large brushes and wet, fluid washes using 2"–4" brushes. The next step was painting the various beach architectures, pavements, cars, parking meters, and pedestrians. Generally I paint from large shapes to small, from background to foreground. The final step here included painting the palms themselves. The palms had to be strong in tone, contrast and colour because all the other elements had been established.

I used straight, clean pigments, and lots of intense washes allowing the pigments to mix on the paper, rather than the palette, to achieve a variety of strong greys. I don't attempt to control the watercolour too much – I allow it to fuse, blossom, and puddle in its own organic way. This creates a nice tension in my work – where the watercolour appears controlled and representational, while at the same time having an organic, spontaneous quality. I paint most of the washes in the middle value range, adding the more intense pigment as time goes on. I leave the whites of the paper by painting around them, and do not use masking fluid. I add depth and clarity to the paint by fusing in lots of clean watercolour too. I try to achieve the given wash on the first try. This is very difficult, as there is very little 'correcting' in a watercolour. But the challenge and demand of getting the value, scale, contrast, fluidity, and colour 'right' the first time is fun!

Once I begin painting a watercolour, I don't stop until the drying is complete. I know that you can manipulate a wash – and then leave the room while it dries, only to return and see that it's done something totally unexpected! I stay with my wash during the drying process, so that I can monitor whatever it might want to do.

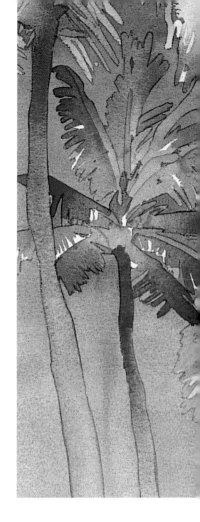

PUDDLING TECHNIQUE

Whilst some artists do their utmost to avoid backruns, Carter's work is characterised by a puddling technique which creates rich colour blends and textures. To achieve this, she not only works flat, but also uses a lot of water which allows the colour to accumulate and mix on the paper without interference. **The results appear** dynamic **and spontaneous.**

Even though its original 72 towers are now reduced to just 14, San Gimignano still makes a powerful statement rising on a hill above the Elsa valley. Bathed in warm, late afternoon sunlight, Alan Reed wanted to capture the languid atmosphere of this historic city.

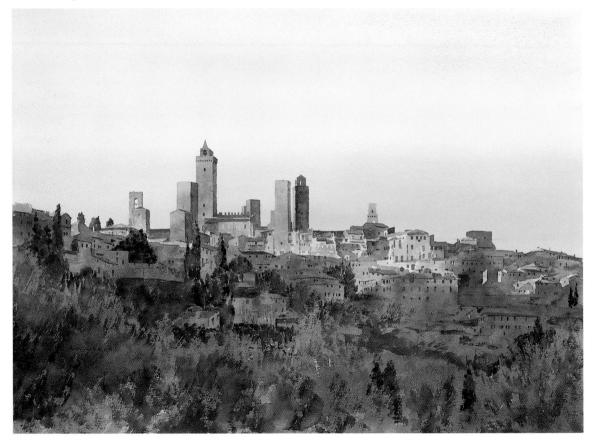

San Gimignano, Tuscany
Watercolour on paper

rodin Art is contemplation. It is the pleasure of the mind which searches into nature and which there divines the spirit of which nature herself is animated.

"

San Gimignano, Tuscany

For a number of years I have been building up an Italian collection of limited edition prints. Before embarking on the finished piece, I like to spend time in the chosen location making at least one small watercolour on the spot to trigger off my memories of the mood and feel of the place. For the painting of San Gimignano, **I wanted to capture the famous towers bathed in the warmth and clarity of late afternoon sunlight, that would evoke happy memories** *for those fortunate people who have spent lazy days under the Tuscan sun.*

Alan Reed was born in Northumberland, into a family with a history of painting. He is a strong Christian, and his faith finds expression in his commitment to his family and through his watercolours.

Alan has had commercial exhibitions since 1981, including at the Mall Galleries, London and the Malcolm Innes Gallery, Edinburgh. His work was selected for exhibition in the Sunday Times Watercolour Competition three years running. Since 1996 Alan has been invited annually to exhibit his exciting rowing scenes in the Stewards' enclosure of the Henley Royal Regatta. His paintings are on permanent display at his own gallery in the Eldon Garden Shopping Centre, Percy Street, Newcastle upon Tyne, which was opened in 1996.

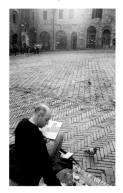

Ponto Rialto, Venice
Watercolour on paper

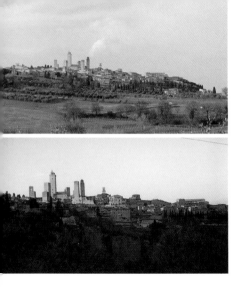

I spent a day and a half driving around San Gimignano, wandering in and out of the town, enjoying the occasional glass of wine or espresso and sampling wild boar salami. I also produced several paintings, but it wasn't until we had left San Gimignano that the sky turned a wonderful pink, creating a beautiful golden hue on the various buildings dotted around the countryside. **I took some photographs from the car and logged the colours in my mind. This was the mood that I wanted to capture as I began the finished piece** that has now been published as a limited edition print.

I prefer to use a limited palette, and for this painting, I stretched a sheet of 300lb. Arches' rough watercolour paper. **I used the photographs purely for technical accuracy of structure and form, so that I could retain the freshness and simplicity of the watercolours produced on the spot**. In this image it is the sky that really sets the mood, so it was important to get this part of the painting just right.

" I produce paintings which are representational but not photographic. I'm concerned about capturing the light and the fleeting moment in time, for which watercolour is ideally suited.

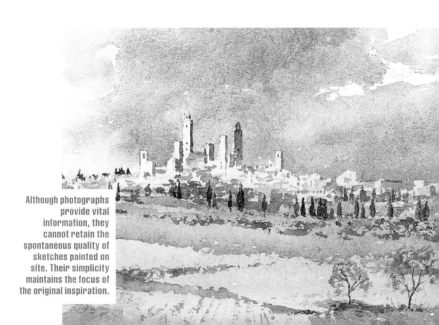

Although photographs provide vital information, they cannot retain the spontaneous quality of sketches painted on site. Their simplicity maintains the focus of the original inspiration.

I began by laying a wash of clean water over the paper. Whilst it was still wet I dropped in a wash of Cadmium Yellow and Lemon, light at the very top of the sky, then becoming more intense at the bottom of the painting. When that was completely dry, I repeated the wash of clean water, then, just above the buildings, I ran in a very subtle wash of Cadmium Red and Crimson Alizarine which continued its intensity to the foreground. Once dry, I wet the paper again and allowed a very gentle wash of Manganese Blue to creep in at the top of the sky, letting it fade into the first wash of yellow.

These washes, full of warmth, provided the perfect tones to allow the buildings to really stand out, painted with the same colours as the sky except much stronger in their intensity. I also used Raw Sienna, Payne's Grey and Van Dyke Brown for the deeper shadow areas, plus a slight touch of Winsor Green for the foliage.

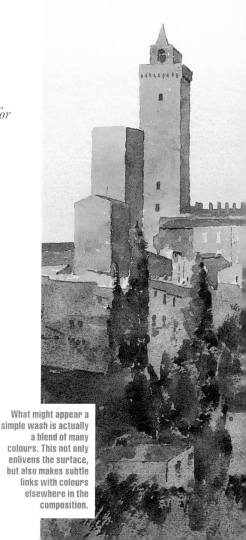

Colours for washes:
Cadmium Yellow
Lemon
Cadmium Red
Crimson Alizarine
Manganese Blue

For extra depth:
Raw Sienna
Payne's Grey
Van Dyke Brown
Winsor Green

What might appear a simple wash is actually a blend of many colours. This not only enlivens the surface, but also makes subtle links with colours elsewhere in the composition.

It is often the small villages, off the traditional tourist routes, that offer the richest pickings for the serious painter. This old Roman village left Bob Wade spoilt for choice, and with an armful of reference material.

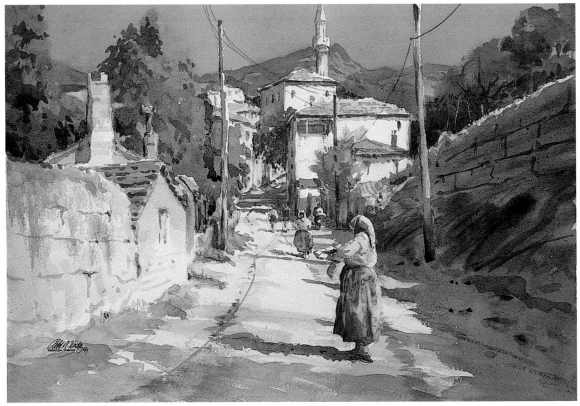

Morning in Heraclea, Turkey
Watercolour on paper

"

Morning in Heraclea, Turkey

Having been rather disappointed by my visit to Istanbul, where I had imagined that I would see something from the last century but found instead a modern city just like so many others, I was quite ecstatic when we chanced upon this old Roman village of Heraclea. **Here was what I had been hoping to find, a place almost untouched by the centuries,** *a place where living was still basic and the luxuries of life were foreign to the local residents. Here was a veritable treasure house of jewels for an artist! I loved the minaret outlined against the azure sky. The architectural style of the buildings was also a symphony of warm reflected light and colour; an old roadway, wonderful figures clad in their indigenous garments, textures, contrasts – what else could I ask for?*

Born in Melbourne, Australia, in 1930, the distinguished Australian artist, Robert A. Wade has gained international acclaim. In 2000 he was elected a Signature Member of the American Watercolour Society, becoming the first Australian to receive that honour. He is also a member of many other watercolour societies in Australia, the UK, the USA, and Mexico, and in 1994 he became a member of the Advisory Committee of the recently established World Watercolour Society.

His work is represented in many public, corporate, and private collections including the Brooklyn Museum, New York, the Royal Watercolour Society, London, the Salmagundi Club, New York, and the Australian Watercolour Institute. He has received a huge number of major awards worldwide.

He has contributed regular articles to Australian Artist and overseas art magazines for many years, and has been Editorial Consultant to Australian Artist and International Artist magazines since their inception. Wade's two best-selling books, Painting More Than The Eye Can See and Painting Your Vision in Watercolour, along with his videos, Watercolour...Wade's Way, and Simply Watercolour, have all received international acclaim.

Robert Wade's paintings are reproduced by arrangement with International Artists Magazine.

The Roman Library, Ephesus

On the Via Dolorosa, Jerusalem

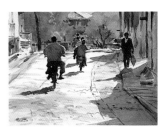

Morning Mopeds, Istanbul

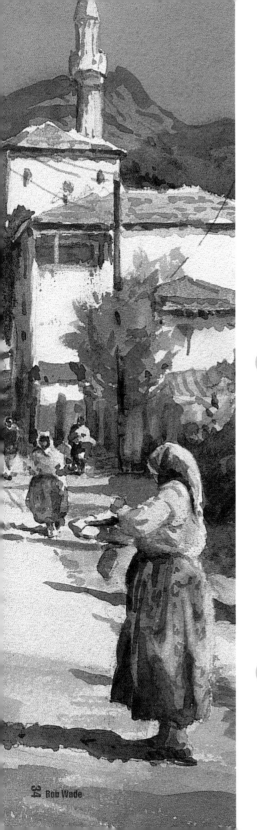

Bob Wade

> " I don't use 'compositional devices' in my paintings; I put shapes where I think they 'feel' right to me. Perhaps the so-called experts might analyse them and work out all sorts of mathematical formulae to give reasons for the positioning of the various elements, but that is all pie in the sky. If it feels right, do it… that's my belief!

seeing

Our tour bus was only staying for a half hour so it was necessary to work quickly. First of all I shot off a roll of 35mm slide film, and, replacing it with a new roll, shot off another. **I ran up the hill and around the little streets clicking off shots like a madman.** Here is one of the great advantages of the camera; the ability to be able to record detail in such a short time. I finished up with 15 minutes to spare which then enabled me to draw some quick sketches of the local ladies who had appeared, as if by magic, to sell their lace to the tourists. **Back home in Australia I was able to merge many elements from the photographs and the figures from my sketchbook to make a comprehensive watercolour** with the mood and atmosphere of that magical place.

thinking

For this painting, I worked on Waterford rough paper. I always paint with rather a restricted palette, and 'Morning in Heraclea' was no exception. The sky was basically Cobalt Blue with Cerulean Blue, but I slightly exaggerated the blue to show out the light value shapes against the sky. Otherwise Raw Sienna, Raw Umber, Light Red, French Ultramarine and Quinacridone Gold were sufficient for me to mix the various greens and earth colours of the road and the buildings. **The more limited the palette, the more unified the painting will be.**

A limited palette for a
unified painting:
Cobalt Blue
Cerulean Blue
Raw Sienna
Raw Umber
Light Red
French Ultramarine
Quinacridone Gold

acting

To achieve the textures, I laid several glazes over the walls and buildings. When completely dry, **I scraped the side of my 2" flat brush down the sheet, making use of the tooth of the Waterford rough paper to give that patina of time to these areas.**

MAKING USE OF A PAPER'S 'TOOTH'

If colour is scraped over, rather than washed, on to a 'rough' surfaced paper, it will naturally produce a textured effect as it skims over the depressions, leaving them free of colour. This is ideally suited to creating the illusion of ancient stonework. Conversely, colour can be carefully scraped off, creating specs of light on the surface of the paper, whilst still leaving colour in the depressions.

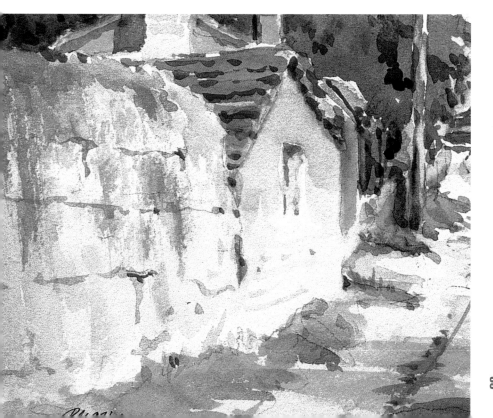

Delivery in the Medina, Fez
More textures, Fabriano rough again, restricted palette and a heap of atmosphere. For centuries goods in these Moroccan cities have been delivered in the same way. Indeed the streets are too narrow to get any vehicle but mopeds through, so animals and humans perform the same tasks which they have done for centuries. Can you smell the atmosphere? Can you hear the hooves clopping on the cobble stones? I sincerely hope that you can, because that is what I try to paint. I do not try to paint a subject how it looks; I want to paint it how it feels!

Market near Marrakech
A super subject, the figures all appear to belong and are not like paper cut-outs or unreal plastic puppets. It's so important to lose some edges and join the shapes in order to allow the eye to flow in and around the painting. A little more colour in this one but still quietly restrained with a fairly limited palette. The white of the paper has been reserved for the strong highlights on the figures. I have used the Fabriano rough paper here as well for the many textures throughout the work.

Gossip in the Souk, Fez

I have a fascination for Eastern figures. Their garments catch the light in magical patterns and rhythms, creating movement and mystery, and are far removed from the normal dress of everyday people we see in our own streets and environment. When I saw these three people in Morocco, they just stopped me in my tracks with a silent mental WOW! Here was a subject which had it all. The only problem was how to record the moment? There was no way that I could draw my normal quick sketches without upsetting my subjects, nor could I upset them by taking a very obvious photo. In these situations, **I have developed a knack of shooting from the hip with my automatic focus camera in order not to cause international incidents!** *I backed away down the alley, appearing to be observing the tops of the buildings but actually getting myself into position for the shots. (What a pity MI5 never got to know of my ability as a spy!) I took 3–4 quick exposures, hoped that I had not taken pictures of gutters and down pipes, and quietly passed on, leaving the ladies to work out how many deenahs they should wager on the local camel races.*

When the slides were processed back home, I discovered that I had two images of blurred windows and doors, but a couple of reasonable results which I could use for reference to tickle up for my figures in the painting. Several quick pencil studies later and the ideas were finally strong in my mind and ready to translate into the finished work. I experimented with the positioning of the people, making sure that the two females were the focal point and the male figure was there for the secondary interest.

I wanted to keep a fairly sombre colour scheme in order to portray the mood of the subdued light in that old alleyway, so the dominant colours used were Raw Sienna, Raw Umber, Cobalt Blue and Light Red. **There is no white paper left at all.** *Before I began the actual painting I put down an initial wash of Raw Umber with a touch of Cobalt and Light Red and covered the surface totally. This was done to lower the value of the light areas and to add atmosphere to the subject. I selected a full sheet of Fabriano 300lb. rough, to assist me in obtaining those wonderful textures on the ancient walls, which help to give mood and feeling to the painting.*

This fabulous composition required the subterfuge of a secret agent in order to capture its natural, intimate quality. A quiet, fairly sombre colour scheme lends authentic atmosphere to the secluded alleyway.

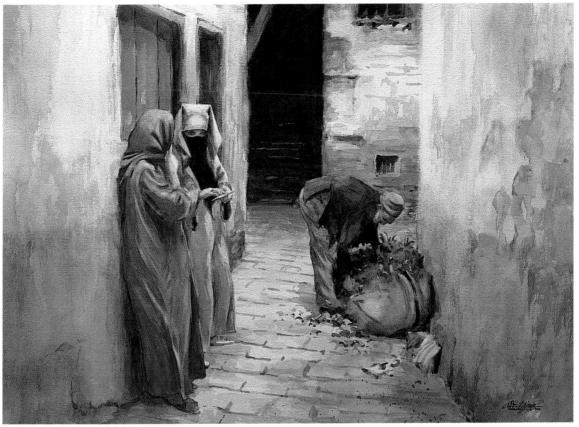

Gossip in the Souk, Fez
Watercolour on paper

cézanne I paint as I see, as I feel – and I have very strong sensations.

37 rural landscapes

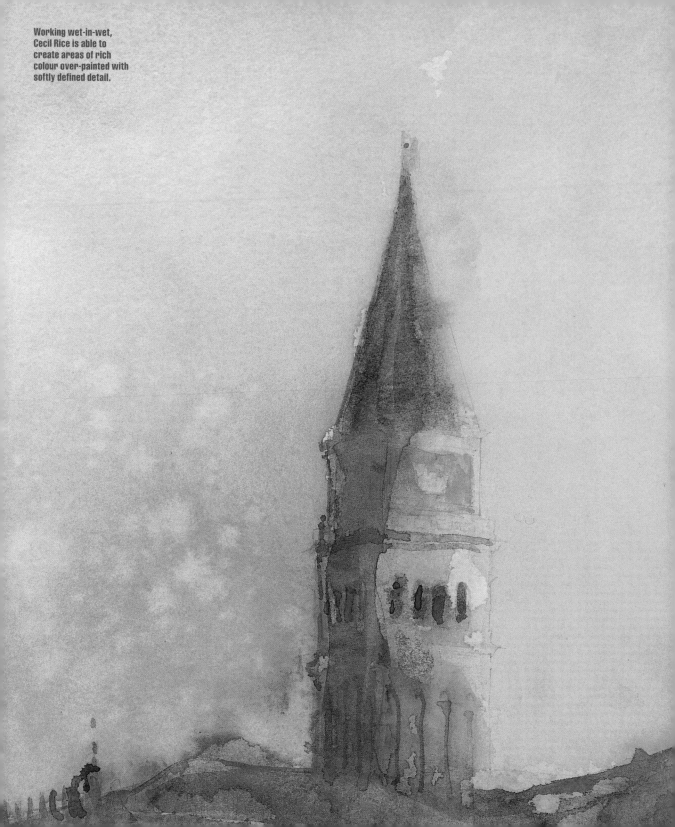

Working wet-in-wet, Cecil Rice is able to create areas of rich colour over-painted with softly defined detail.

seascapes and waterways

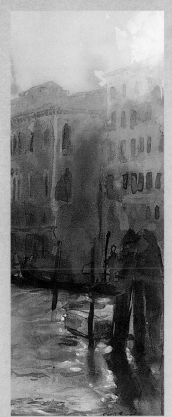

Details from
'Sunset over St Marks',
Cecil Rice.
Reflecting light from any
and every source, the
presence of water
enlivens the environment,
adding movement and a
further dimension to a
painting.

Portloe is one of Cornwall's most attractive coastal villages. It remains unspoilt, full of reminders of its fishing heritage and wedged in its dramatic setting under looming cliffs. Its contrast of textures and shapes provides an ideal subject for artists.

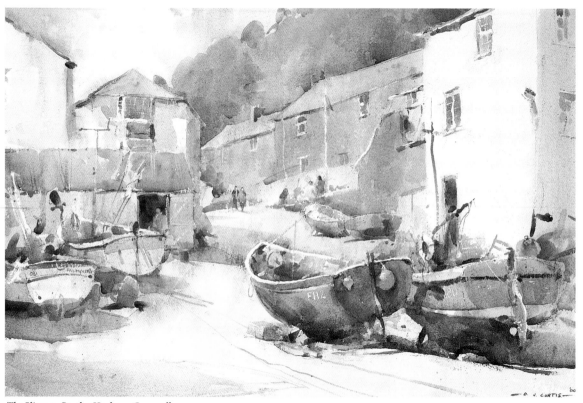

The Slipway, Portloe Harbour, Cornwall
Watercolour on paper

The Slipway, Portloe Harbour, Cornwall

Portloe lies within the Roseland Peninsula in Cornwall. Whilst it is small in comparison to more visited venues like Polperro and Mevagissey, **it has a lovely intimacy** *and certain similarity to Cadwith Cove and maybe Port Isaac, i.e. basically a 'cut in' to a hillside, and a safe and sheltered mooring for small vessels. On the day I was there painting, an old unwanted vessel was, as is the custom, unceremoniously burned on the beach. Apologies were made to me by the locals for the smoke billowing on occasions in my direction, obliterating at times, my view of the subjects. Just one of the trials and tribulations for the 'plein air' painter!*

The Beach at St Ives

This was produced in a very similar manner to 'The Slipway', **with some 'punchy' architectural features relating to the more diffused backcloth of the distant hillside***. Particularly of note, I feel, is the treatment of the vessels in the foreground, produced rather as a suggested mass, with little areas of detail accented upon when necessary. This avoided reproducing too much obvious detail and a consequential 'tightening up' of the image as a whole.*

Born in Doncaster in 1948, David Curtis headed an engineering design team until 1988 when he became a full-time painter. He was elected to the Royal Society of Marine Artists in 1983 and became a member of the Royal Institute of Oil Painters in 1988. In 1992 he won first prize in the prestigious Singer Freidlander/Sunday Times Watercolour Award, and second prize in 1997. The following year he joined this competition's selection committee.

David works in both watercolours and oils, preferring to work 'en plein air' where he is concerned primarily with transient lighting conditions and the effects of atmosphere. He has written two books on landscape painting supported by videos, and he also exhibits widely.

David Curtis (right) with Trevor Chamberlain, on location.

The Beach at St Ives
Watercolour on paper

This immediate 'plein air' subject was chosen for its strong directional composition and broad shapes. I was working between ten and twelve in the morning when an optimum light effect was afforded, although the general conditions on the day were of intermittent sun and scudding cloud masses.

I wanted to state some areas simply by leaving relatively untouched paper. **The moored vessels provide a lovely sense of a lead into the scene**, whilst a broad and 'blocky' backcloth of a wooded hillside provides a mid-toned area which allows the line of cottages to stand out in relief, pushing nicely forward of the tree mass. **Many of the shapes are restful and uncluttered, with very little attention paid to unnecessary detail – reserving this for the vessels on both sides of the subject** and some added detail interest on the little workshop on the left. Some figurative interest is afforded within the dark recess of a door opening and some figures in the middle distance.

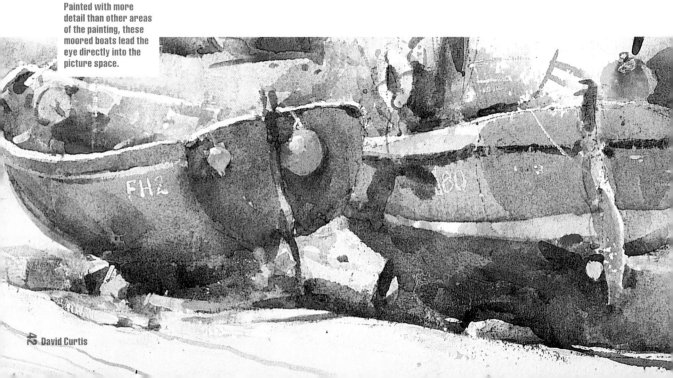

Painted with more detail than other areas of the painting, these moored boats lead the eye directly into the picture space.

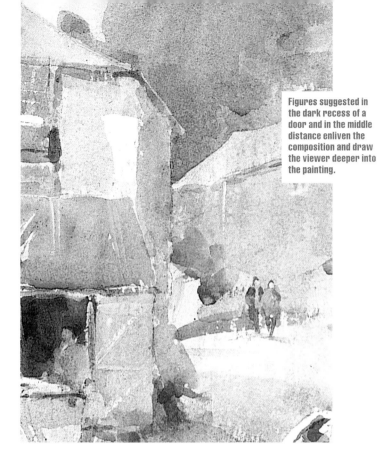

Figures suggested in the dark recess of a door and in the middle distance enliven the composition and draw the viewer deeper into the painting.

acting

I worked on stretched paper (300lb. Arches' rough) with much of the early colour application worked wet-into-wet. Stretching the paper is necessary since **I like to quickly affect a firm statement of the image before me by flooding in a broad wash, echoing all the tone and colour variations as they are presented**. This takes practice to achieve. I need to be able to observe, adjust the colour mixes accordingly, and place this totally fused initial wash, whilst avoiding any hard edges. Large reservoirs of colour are necessary for this procedure, preferably using a no.12 or 14 sable to apply the wash. A quality sable of this size is capable of holding a large reservoir of colour and so assists the speed and decisiveness of application. I used a limited palette of French Ultramarine, Cerulean Blue, Cobalt Blue, Cobalt Violet, Raw Sienna, Cobalt Green, Burnt Sienna, Winsor Lemon and Viridian. **Overall it was a quick impression, produced in about two hours**.

A limited palette for working quickly:
French Ultramarine
Cerulean Blue
Cobalt Blue
Cobalt Violet
Raw Sienna
Cobalt Green
Burnt Sienna
Winsor Yellow
Viridian

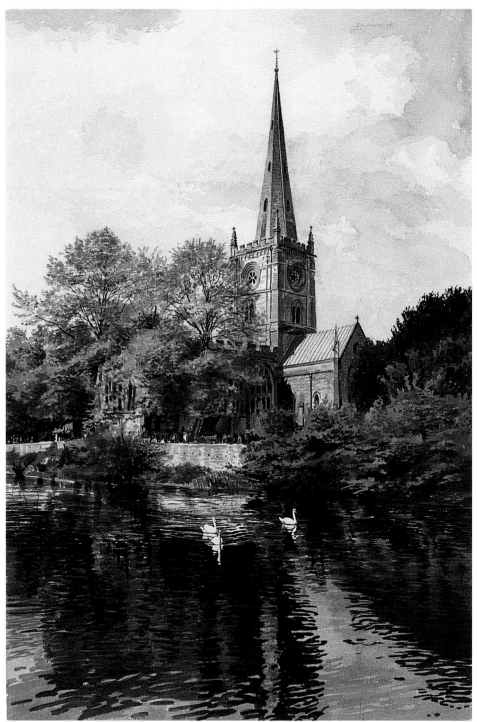

This very English scene provided Louis Gadal with some strong compositional features. The reflection on the river and the interest of the white swans lead the eye back to the church rising out of the trees. The vertical thrust of the spire is then counter balanced by the gentle horizontality of the river bank.

Reflections on the Avon
Watercolour on paper

"

Reflections on the Avon

This painting was completed from my first trip to England. My wife and I loved the English countryside. We spent some time in the Cotswolds and a great many paintings resulted from this trip. One place that particularly moved us was Stratford-upon-Avon, and the history we found there. This painting is of the Holy Trinity Church in Stratford, and is the place where William Shakespeare was laid to rest. **I find painting water and reflections a real challenge**. There were white swans swimming up the river, breaking the reflection and adding a nice focal point in the middle foreground. The tower of the church seemed to rise up and out of the trees that surrounded it – a powerful statement against the light, bright sky.

Award-winning artist, Louis Gadal showed an early talent for drawing. Born in 1936 in Los Angeles, he gained a four-year scholarship to study at the Chouinard Art Institute, LA, where Rex Brandt and Edward Reep, two noted Californian watercolourists, were among his teachers. He went on to develop expertise in printmaking, and currently works in watercolour, acrylic and egg tempera, on varied subject matter.

For the past twenty years he has maintained his own architectural illustration firm, where he has worked on such projects as the Corning Museum in New York, the Rockwell Museum and centre for Western Art in Corning, New York.

Gadal exhibits extensively and is a signature member of the Niagra Frontier Watercolour Society, the Pennsylvania Watercolour Society, Watercolour West, the National Watercolour Society, and a signature member of the American Society of Marine Artists. His entries for the American Watercolour Society have been selected three times for the Society's Annual Travelling Exhibition. He has regularly made the final 100 selection for the Arts for the Parks, Jackson Hole, Wyoming. Listed in Who's Who in America, Gadal's work is owned by museums, corporations and private collectors.

Los Olivos
The Eppleton Hull

I start most of my paintings on location by making drawings or small watercolours on my watercolour blocks. **I try to envision elements into compositions that best tell the story about the subject.** *In drawing the subject you become familiar with it, and develop an understanding of what you are painting.* **I think it is almost necessary to live in the environment you are painting to really tell a true story.** *I know when I first go to a new location, I spend the first day just looking and taking in all that is there, making paintings in my mind, as I make my observations. It is important to put down an idea quickly, when it is fresh, so that you do not lose the moment. This is the approach I took here.*

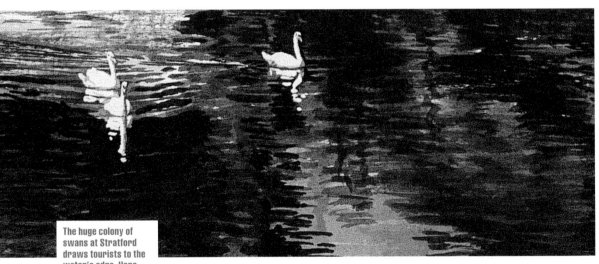

The huge colony of swans at Stratford draws tourists to the water's edge. Here they add life and movement, providing a focal point in the middle foreground.

On returning to my studio, I laid out my ideas and studies. From here I solidified my concepts and composed the painting. I use 140lb. hot-pressed paper for most of my watercolours as it does not have the texture of cold-pressed and rough. It lends itself more to the dry brushwork that I do. I do have to tape it down to a solid surface, and after I finish the work, I leave it there over night so that all the moisture dries out of the paper. **I always start with a good pencil linear outline of the subject.** *I may not follow it exactly, but I feel it is necessary.*

Colour can be given more body by layering one colour over another. Gadal does this using a dry brush which, although relatively slow, gives him more control and does not disturb the underlying colour. There is the added benefit of achieving a livelier surface as the colour builds texturally, creating a greater sense of depth.

acting

Going in with the colour, I started with what I call under-painting, and with the large areas like the sky. I tend to make my skies very light, since in nature the sky is generally the brightest element. **With watercolour you rely on the white of the paper for your highlights, so do not over-paint your skies**. *I often paint a critical dark early in the work so that I might adjust my colours to the dark elements of the painting.* **I feel strongly that watercolour does not have to be a 'light', 'under-painted' medium. By layering one colour over another, I can achieve more body and greater depth – a technique I used in this painting**. *To a large extent my method of working was influenced by my experience of working with egg tempera. With this medium you have to work the paint into the surface as the paint has a tendency to stick to the brush. I used this dry-brush effect in my watercolour paintings and found I had much more control over the things I was painting. Applying paint in this way does not disturb the underlying colour, and, although it slows the process of painting down, I find the results more to my liking.*

This lighthouse, commonly known as the Nubble Light, is located on the southern part of the Maine coast just north of Portsmouth, above York Harbour at the north end of York Beach. It is located on a small granite island just off shore. The tower was built in 1879. It can be seen easily from the shore, which has made it one of the more popular lighthouses in Maine. The echoes of Hopper are no coincidence. Gadal undertook a special study of Maine lighthouses, seeking out those painted by artists he admired, including Hopper. He felt he was seeing Hopper's subjects through the latter's eyes, whilst at the same time experiencing them for himself.

duty When I feel a little confused the only thing to do is to turn back to the study of nature before launching once again into the subjects closest to heart.

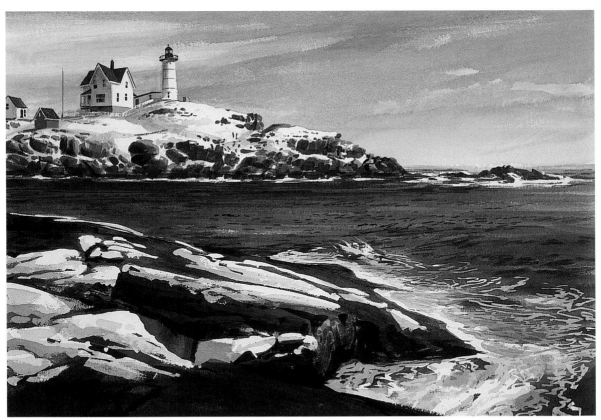

Cape Neddick Lighthouse
Watercolour on paper

Getting to know your subject: The initial study in pen and ink provides detailed structural and tonal information.

A watercolour sketch is invaluable not only to note the natural colours, but also to assess further the tonal balance.

The final harmonic composition draws on all the preparatory work and effectively leads the eye into the picture space.

LOUIS GADAL'S TIPS

understanding

Most of painting is about understanding your subject and gaining knowledge about it. I feel that the more time you spend in drawing, the more you are aware of the subjects you are painting. The other part is making lots of mistakes, and ruining a lot of paper! I recommend that you jump in and start making the mistakes! With each one you can gain so much in the craft.

learning

There are three ways that we learn: The first is by doing. The more you do, the more you advance.

The second is by associating with others who are interested in working hard to try to advance themselves in the same way, and sharing ideas.

The third is to find a good instructor who is working in the area or medium in which you are interested. Be careful to choose one who does not impose his own style on his students. I always list the instructor last, because if you do not work at the first two, you will never advance yourself.

With watercolour paper try not to do too much erasing as you can disturb the surface. I use an eraser called 'magic rub' which is less abrasive than others.

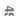

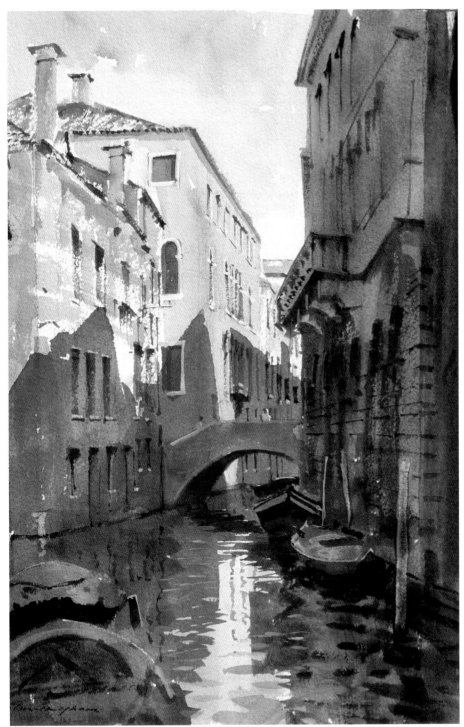

The light in Venice is unique and it draws artists back to its waters again and again. Michael Felmingham is particularly attracted to the atmospheric and more intimate canals, away from the traditional tourist routes.

Canal Scene, Venice
Watercolour on paper

"

Canal Scene, Venice

I first visited Venice in 1974, and now return almost every year specifically to draw and paint. I love the unique quality of light that varies so dramatically as the sun moves over the city. Although I paint the set pieces of this theatrical venue, **I am drawn to the more intimate waterways which catch the light in atmospheric, and often unexpected ways**. *I try to work on the spot whenever possible, but sometimes it is necessary to make sketches or take photographs which I can then work from back in the studio.*

Sea Mist at Mousehole

This started as a study of rocks on a bright summer morning, but gradually **the sea mist came in and obscured the town and distant headland, bringing an element of magic to the scene**. *The beauty of working on the spot is that you are at the mercy of the changing weather in this country at least, and this can sometimes be beneficial. To capture this transient effect, I mixed up a half-cupful of White Gouache and a touch of Cerulean Blue, and literally poured it over this part of the picture, completely obscuring it. As it gradually dried off, the scene beneath came through again. A risk worth taking which, on this occasion, worked well.*

Born in Birmingham, UK, in 1935 Michael Felmingham taught for many years at Leicester and Coventry Colleges of Art. He now devotes all his time to his own practice; painting houses, gardens, towns and cities. His paintings of Venice have become particularly well known. Michael has been well represented at W.H. Patterson's Venice in Peril exhibitions for a number of years, and his work has been widely exhibited at the Royal Academy, the Royal Society of British Artists, and other major galleries in London.

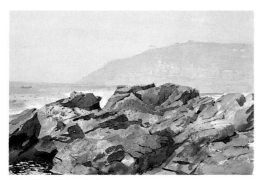

Sea Mist at Mousehole
Watercolour on paper

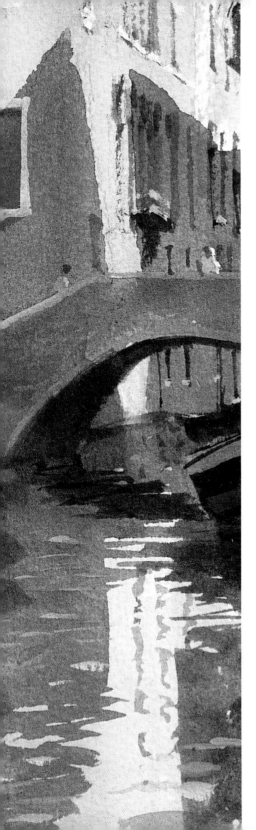

This is a typical Venetian scene; a quiet, almost unruffled canal, strong warm sunlight and deep shadows. The shadows were the only thing that moved, and so I needed to put them in quickly. **The main point of interest, and focus of the picture, is the streak of sunlight, which reaches down the wall in search of its reflection just under the bridge.**

Michael enjoys dropping a touch of Winsor Violet into the shadows, or adding a little Sap Green, both of which help give his paintings a bit of punch.

I tend to use a fairly limited palette, working from an old enamel watercolour box that includes the odd 'wild' colour such as Winsor Violet and Sap Green. I also carry a tube of White Gouache. **I find a mix of Cerulean Blue, Raw Sienna and White produces a lovely warm grey, highly suitable for the shadows.** For this particular painting I needed mainly earth colours.

I chose to paint on a fairly heavy Arches' medium, or 'Not-pressed' paper, which had been taped to a board with masking tape. I never stretch my paper since I find this alters the surface as the gelatine loosens.

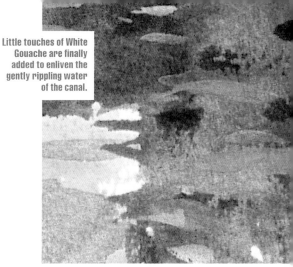

Little touches of White Gouache are finally added to enliven the gently rippling water of the canal.

I worked fast with a largish, but well-pointed, no.12 brush, over a light pencil sketch, the lines of which were kept to a minimum. **I do like to go in with my hands**. I can create interesting textures for decaying doorways or walls by pressing the palm of my hand into the paint. A spattering technique is also good for a battered door. My fingernails come in useful to add a texture or to lift out a highlight, as I did here to create the detail of the mooring post in the foreground. I also used little touches of White Gouache on the water.

I always carry tissues so that I can make rapid changes. With a heavyweight paper, **contrary to popular belief, it is possible to rework a passage successfully** after a wrong mark has been made. Overall it took me about forty minutes to complete, by which time the sun had moved on.

Cerulean Blue, Raw Siena, and White can be mixed to create a lovely warm grey, ideal for shadows.

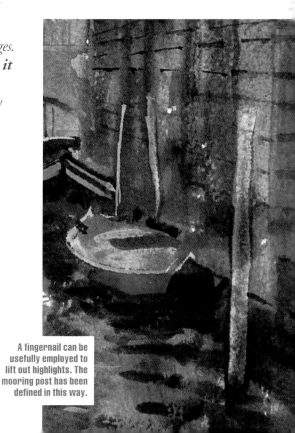

A fingernail can be usefully employed to lift out highlights. The mooring post has been defined in this way.

USING YOUR HANDS TO CREATE TEXTURE

Felmingham is a great believer in using your hands to help create texture. It saves on carrying extra equipment out into the field, and a variety of interesting effects can be easily achieved. It will take some confidence, since to a certain extent the results can be unpredictable. Practise on scrap paper back in the studio, and you will find it is well worth getting your hands dirty. Experiment with pressing anything that you might find lying around your studio into the paint, or using it as a drawing tool – you never know what techniques you might discover.

By pressing the palm or side of the hand into the paint once it has just begun to dry off, natural shapes and textures form – suitable for ancient walls or mossy paths.

A fingernail drawn through the paint can produce an accent of white to highlight an object, giving it form and definition, or giving texture to the paint to suggest grass or perhaps some distant trees.

Even a smudge can give the sort of immediate effect which enlivens a painting to suggest movement and vitality. Getting your hands dirty requires some confidence, but experimenting will give you some surprising and interesting results.

> ### Frozen Fields at Old Milverton
> *This very large watercolour took two days to complete and was necessarily done in the studio from drawings and photographs. From the gateway the cart tracks fanned out across the frozen field towards the distant cattle, creating interesting patterns and measuring the distance. I started very roughly on a full sheet of Saunders Waterford not-pressed paper with large washes and much spattering of paint; the hedge painted wet-on-wet, also the blurred distance. Frost patterns in the foreground ruts are picked out in White Gouache. **I like the wet and wild start to such a picture** and the gradual accretion of detailed marks that allow me to get into the subject, and trying to keep the two things in balance.*

You can feel the chill in this expansive landscape, where cart tracks cut through the frost, leading the eye to the distant signs of life.

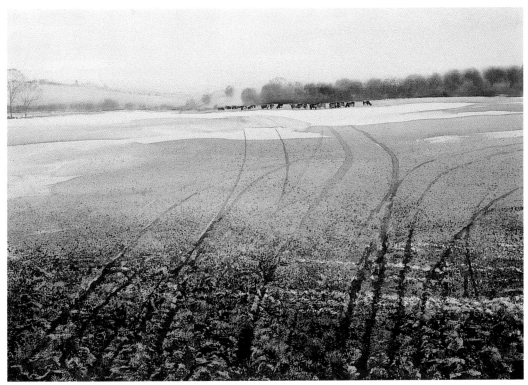

Frozen Fields at Old Milverton
Watercolour on paper

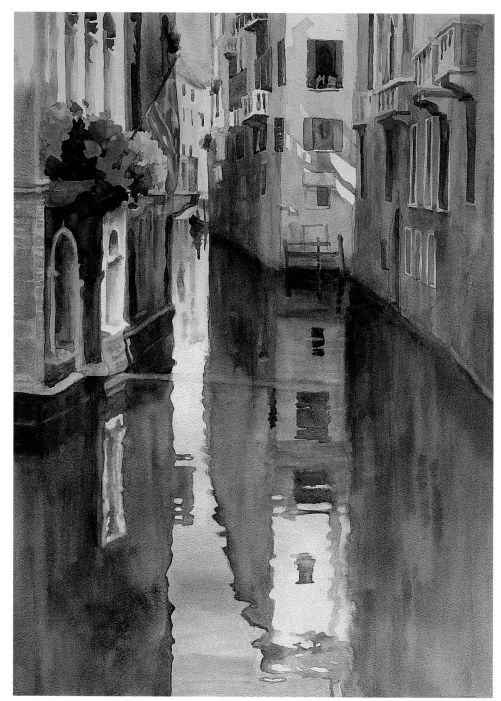

Venetian canal scenes tend to demand a vertical format. Jann Pollard capitalises on the intriguing shapes created by the dark reflections and shadows discovered in one of the city's backwaters.

Rio Menuo de la Verona, Venice
Watercolour on paper

Rio Menuo de la Verona, Venice

Although I am a studio painter, it is so important to work on site to capture the feelings and emotions that attracted me to the composition in the first place. **The light, textures, smells and sounds are all key to the atmosphere behind the development of a painting.** *When travelling, I sketch, make colour notes, and take photographs. I work on these back in the studio, and now frequently use the computer as an exciting tool to assist in the development of compositions.*

Jann Pollard is a Signature Member of the National Watercolour Society, California and the Society of Western Artists. Whilst travelling and using (as she so often did), one of Karen Brown's lauded travel books, she painted one of the remote villages featured within it. The painting caught the attention of the author and she is now the cover artist of Brown's series. Her work was recently featured in International Artist magazine and can be seen at The Cottage Gallery in Carmel, CA, The Gallery in Burlingame, CA, and The Generations Gallery in Napa Valley, CA. Her works are in private and corporate collections internationally.

Pollard's book, Creative Computer Tools for Artists, written in collaboration with Jerry Little, is published by Watson-Guptill. It explains how Pollard uses the computer to do her compositions and colour studies before she starts painting, showing how the computer can be a new tool for the artist, rather than simply producing computer art.

Dusk on Canal

Venice Textures
Watercolour on paper

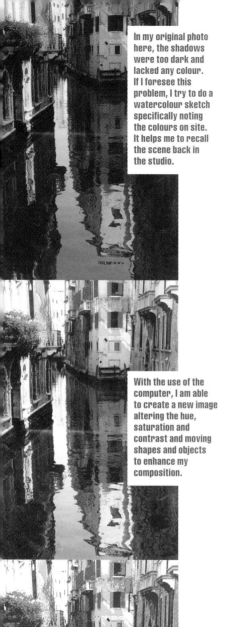

In my original photo here, the shadows were too dark and lacked any colour. If I foresee this problem, I try to do a watercolour sketch specifically noting the colours on site. It helps me to recall the scene back in the studio.

With the use of the computer, I am able to create a new image altering the hue, saturation and contrast and moving shapes and objects to enhance my composition.

Often, as in the black-and-white image shown, I break my composition down into just three values. I am able to paint loosely and enjoy applying the textures and colours intuitively because I then have a 'map' of where I am going.

On a recent trip to Venice, **I was completely intrigued with the dark, black reflections of the canals**. They seem to be darker than any other city and create wonderful shapes for the artist to work with. This scene appeared as I turned a corner. One is always lost in Venice, but that is the fun of it. You discover areas where the tourist would not ordinarily go. Venice scenes definitely require a vertical format with their deep narrow reflections.

I always plan my compositions in grey scale before starting a painting and use them as a 'map' to know where I am headed. It gives me direction on which shapes will be light or dark, warm or cool. Once I have done my study and know where my lights and darks are, I paint shapes, not things. Think of it more like a puzzle. The whole thing doesn't pull together until you place that last piece of the puzzle. **I couldn't paint like I do, unless I had my value study. A computer is very useful in this context**. An image can be scanned in, and the computer can then automatically present it as a value study, from which the optimum balance can be decided upon.

Light and texture are key elements of my compositions as I strive to capture the essence of the scene. I worked on stretched Strathmore Gemini 140lb. cold-press paper, and to achieve the feeling that I was after, I had to paint the water reflections in several layers, adding a different colour with each layer. **When I am painting I often invent the colours and do not follow the photo or sketch explicitly**. Aureolin, Scarlet Lake, Quinacridone Coral, Permanent Rose, Winsor Red, Permanent Crimson Alizarine, and Cobalt Violet were all used here, along with a range of Blues and Ochres.

USING TRACING PAPER TO CREATE INTERESTING TEXTURES

Pollard has discovered a superb technique to simulate the texture of old buildings. Using combinations of thick paint, applied to wet paper, she then places a piece of tracing paper on to the damp shape. After a while she peels it off, judging the time in relation to the exact texture she requires. The longer you leave it before peeling it off, the greater the resulting textural surface. The surrealist, Max Ernst, used a similar device to create sumptuous textures for feathers and plant life.

I add layer after layer of transparent watercolour. The key to achieving the depth of colour is timing – knowing just when to go back into the shape without causing mud. Creating texture is done in a number of ways. **One technique I use for texture on these old world buildings is after wetting a shape, and dropping numerous colours into it, I place a piece of tracing paper on the damp shape**. Again, it is a bit tricky as you have to use thick paint, and timing is quite important. The longer you leave it there, the more texture you will have when you peel it off. I also put watercolours in small spray bottles and often use them to soften an edge or create texture.

Spray bottles can come in handy either simply to wet an area of paper, or to carry paint itself. Either way they can be used to soften edges or to create texture.

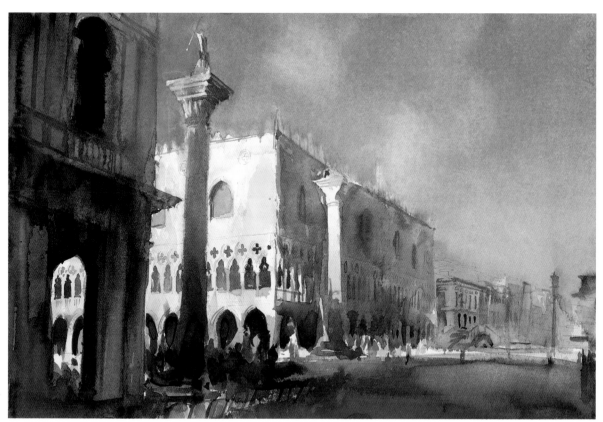

The Doge's Palace
Watercolour on paper

Venice's set pieces can become a bit of a cliché for artists. However, such magnificent architecture, combined with serendipitous dramatic lighting, can produce results that are pure theatre.

"

The Doge's Palace

Every so often I experience the need to attempt something dramatic. Such was the case with The Doge's Palace. I was walking back towards St Mark's Square one spring evening, and came upon this inspiring view. The late afternoon sun produced an effect of floodlighting parts of the architecture, whilst leaving other parts plunged into shadow. It provided me with an exciting opportunity to create a sort of stage set and a romantic one at that. **When I see something like this, I tend to get an immediate image of a painting in my mind's eye, and a feeling of tremendous excitement at the inherent possibilities.** *I always stop and make an immediate record either in pencil or in watercolour, otherwise the impression can be lost.*

Born in 1961, Cecil Rice has lived in Brighton since 1974 and studied painting at Brighton College of Art. Rice is well known for his evocative paintings of shoreline subjects and architecture. He has a passion for Italy, especially Venice, and travel has been an important inspiration behind much of his painting to date. Rice's work is sought after by corporate and international clients. Limited edition screen prints of his work can be found in London and New York galleries. His work is exhibited regularly in London and the South East of England, in mixed exhibitions and one-man shows.

Evening Light, Shoreham
Sunset over St Marks
Palace Pier, Evening

A setting sun offers seductive combinations of warmly glowing evening light against the cooler encroaching shadows. Avoiding sentimentality, Cecil Rice capitalises on the atmospheric possibilities of this magical time of the day.

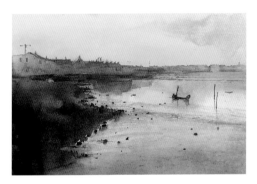

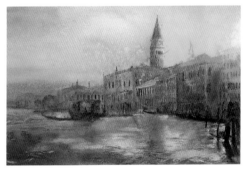

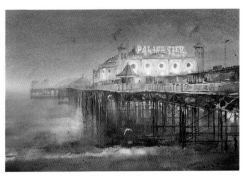

ruskin The purest and most thoughtful minds are those who love colour the most.

Yellows to purples:
New Gamboge
Raw Sienna
Cerulean Blue
Cobalt Blue
Ultramarine Blue
Crimson Alizarine

The sense of drama and atmosphere was achieved through the combination of several interrelated factors. Contrasts of tone were of key importance. For example, **the building on the far left is steeped in shadow, whilst in energetic contrast, one can see the floodlit side of the Doge's Palace beyond.** This wall of yellow is the brightest element of the composition. However, here too, the shadows can be seen in the shapes of the Gothic windows and archways. These shapes punctuate the side of the palace almost like repeated exclamation marks on white paper. This active area draws our eye, leading us some way into the space of the painting. On its way towards the floodlit side of the palace we are forced to acknowledge a high vertical column whose base is deep in shadow. This, and other clear verticals within the painting, add to the sense of scale and tend to take the eye upwards. **The sky is the most restful part of the composition possessing a neutral tonality approximately half way between light and dark.** This area is very necessary, considering the activity and drama of the rest of the painting. One more thing worth noting is the strong horizontal emphasis given by alternating bands of light and dark across the pavement.

The sharp contrast of deep shadow from within the floodlit wall, draws our eye to the active area some way into the picture space.

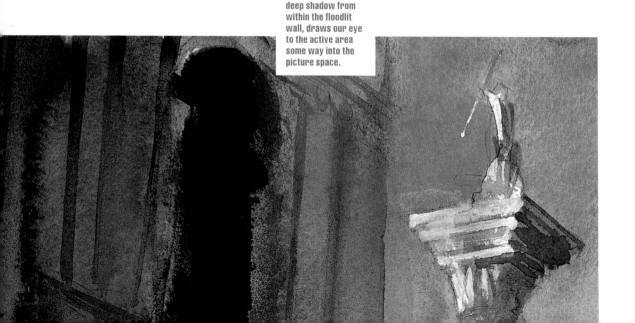

Looking at colour in this painting there is, again, an emphasis on contrasts. The sunlit face of the Doge's Palace is largely yellow whilst the long front is mainly violet. **I did not set out with the intention of using such an obvious complementary colour scheme but the dynamic between yellows and purplish colours in this painting is undeniable.** New Gamboge and Raw Sienna were two important yellows whilst I mixed the violet colours utilising several blues (Cerulean, Cobalt and Ultramarine) and Crimson Alizarine. The building to the left is in cool bluish shadow which throws the warmer sections of the painting into relief. Incidental details such as a few flecks of red or little breaks in the surrounding area of dark wash suggest the activity of distant figures. **I had no preconceived notion of this painting as being like a spot-lit stage, but the effect is evident and I can almost imagine actors waiting to make an entrance.**

The painting, like many of my larger watercolours, was executed in the studio. It is very difficult to protect a large surface of stretched watercolour paper from such intruders as raindrops, particles of dust, and flies, all of which tend to ruin the work.

For larger paintings I like to stretch the paper so as to achieve a flat working surface. At the outset, **I almost always apply clean water universally across the paper with a flat brush and then 'drop in' certain colours, letting them run freely to create ambient areas.** I work from light to dark, being careful not to lose the clarity of some of the lighter passages. Later on, I re-wet the paper so as to make the surface receptive to the paint once again, but I then allow much of the water to evaporate. This leaves me with subtly damp paper into which stronger suggestions of form and colour can be placed using largish soft brushes. Before the painting is completely dry, it is possible to draw more definite lines and tonal shapes into the composition and not have them run or bleed. Nevertheless, this sort of wet-in-wet work will still appear soft once dried.

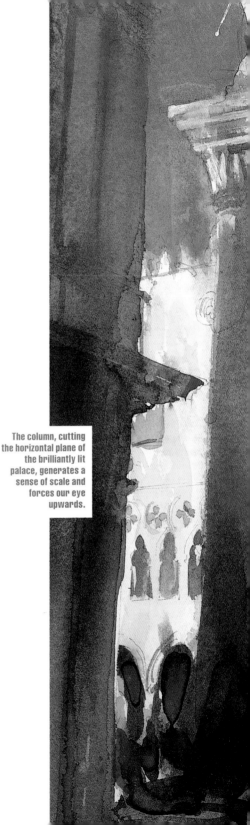

The column, cutting the horizontal plane of the brilliantly lit palace, generates a sense of scale and forces our eye upwards.

Turquoise Lake at Krisuvik
Watercolour and body colour on paper

Turquoise Lake at Krisuvik

In 1994, my daughter Sophia and I travelled for the first time to Iceland, to experience a different world. Since our journey there by container ship took five days, we had an appropriable sense of a true journey from a familiar place to somewhere very different. What we experienced there made the deepest impression on us, and we have been painting images of it since.

We found an elemental landscape, entirely lacking the highly developed overlay of cultivation that we know in England. Iceland is still in formation, with active volcanoes and lava fields, steam vents and hot pools. **Forms are often bold, stark, and with strong contrasts of colour and tone.** *The colours of the landscape entranced us: blacks and greys of volcanic ash plains and lava fields, whites of glaciers, deep blues of distant mountains, astonishingly vivid colours in the rocks, and turquoises, blues and greens in lakes and pools.*

Jacqueline Rizvi

Jacqueline Rizvi was elected a member of the New English Art Club in 1982, a full member of the Royal Watercolour Society in 1983, and a member of the Royal Society of British Artists in 1992.

She was born in Yorkshire in 1944 and studied painting and art history at Regent Street Polytechnic and Chelsea School of Art, after which she worked as a lecturer and illustrator. She has exhibited internationally, and has received commissions from clients such as Saatchi and Saatchi, London Clubs Ltd., London Underground Ltd., and two London medical schools. Additionally, her work can be found in the collections of Inter Alia, the British Museum, Shell, Amoco, and the Davy Corporation.

Fumerole

Although the lake looks to be in the middle of nowhere, it's close to the road (one of the few in Iceland). On the other side of the road is an area of steam vents, runnels of boiling water, and rocks covered with richly coloured chemical deposits. 'Fumerole' is based on this scene.

Fumerole
Mixed media

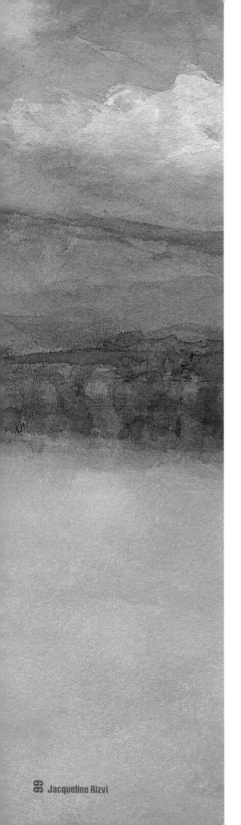

The lake at Krisuvick, in a geothermially active area on the Reykjanes peninsula, is among the best known and most striking of these beautifully coloured lakes.

I was struck by both the beauty of the colour – deep green turquoise of the water, cool blue in the sky, dark ash grey of the bank, and the stark simplicity of the motif – a nearly circular lake, its edges masked by foliage and the hills beyond. **No buildings, no animals, no people – a feeling of remote serenity**.

Cool watery colours dominate over earths and reds in 'Turquoise Lake at Krisuvik': Cerulean Blue Viridian Black Cobalt Blue

I painted the picture some time afterwards, working from notes, and from memory. I usually paint landscapes away from the motif – out of necessity, when it is not practical to work for hours on the spot, and preference. **I find working from memory better retains the purity of the first impression. The painting did not work easily; this painting is the third attempt**. First I tried a wider horizontal composition, with a lower eye level. But the shallow ellipse gave insufficient emphasis to the jewel colouring of the lake; the nearer shore was a distraction, as was the large expanse of sky. The second version was almost all lake, with no sky, and was not right either, as it did not convey the surprising sight of a brilliantly coloured lake within an austere muted landscape. Finally I painted the lake expanding through much of the picture space, with the surrounding landscape and sky in the upper register of the composition.

USING CHARCOAL TO CREATE TONAL AREAS

Rizvi uses rubbed charcoal as a basis for establishing areas of varying tone and texture. Painting transparent colours over the charcoal creates an interesting depth of field.

acting

*I often work on toned papers – **buff, blue or grey**; but this time I chose white paper (Saunders Waterford) to provide a brighter ground. I washed the paper first with a pale blue tint at the top, graduating to delicate earth at the base. Then I built up successive layers of colour washes – predominantly Cerulean and Viridian in the lake; Black, Umbers, Light Red, and Viridian in the surrounding land; and mainly Cobalt graduating to Indian Red, Ochre, and Naples Yellow in the sky. I used body colour washes to convey the milky quality of the turquoise, and to give body to the gradations in the sky, and the drawing of the clouds.*

*In contrast to the cool colouring and deep space of 'Turquoise Lake at Krisuvik', 'Fumerole' is composed in warm colours, and focused closely on the details of rocks and stream. The paper is a lightweight white paper, which I prepared with washes of pale earth. Over this **I blocked out tonal areas in rubbed charcoal and drew detail of rocks and ground texture in charcoal, pencil and pen**. Layers of Ochre, Indian Red, Light Red, Naples Yellow washes were built up over the underlying drawing, and the rocks further developed in touches of Ochre, Earths, Reds and Naples Yellow. I used mixtures with White to indicate the sinter surrounding the vents, and the plumes of steam.*

Hot and cool, active and calm: the two paintings can be seen as a contrasting pair.

Warm colours create the atmosphere in 'Fumerole':
Earths
Reds
Ochres
Umbers
Yellows

A sketchbook might not
be the first thing you
would pack on an
expedition to the
mountains, but for some
people, the combination
of the physical and visual
challenge is irresistible.
The crisp mountain air,
the dazzling sunlight, and
the sheer awesome scale
of the venue, provide one
of the most dramatic
subjects in an artist's
repertoire.

rocks and mountainscapes

Details from
'Breakfast with Henry',
Rob Fairley.
Painting in the mountains
poses problems most
of us would not even think
about. Whilst it is
common to consider
the drying time of
watercolour, imagine the
difficulties of working
with paint that is neither
wet nor dry, but simply
frozen on to the paper!

There are few sights more spectacular than watching a clear dawn break in the mountains. The peaks glint with an almost impossible brilliance, whilst fingers of light steadily invade the deeper shadows, articulating their uncompromising features.

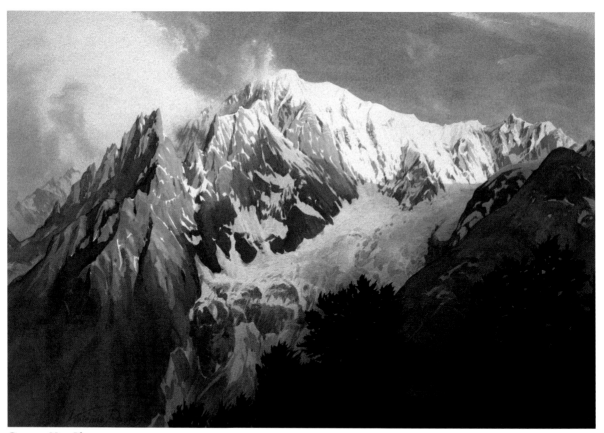

Dawn on Mont Blanc
Watercolour on paper

Dawn on Mont Blanc

In 1999, I walked the Tour de Mont Blanc, with the idea of bringing back reference material, including sketches and photographs, to do large watercolours. This was very successful, and led to a wonderful walk, inspired painting and lots of sales! The work depicted is of Mont Blanc, the highest mountain in Europe at 4808m, the Aiguille Noire de Peuterey, and Glacier de Brenva.

Vivienne Pooley was born in London during the war, in 1944. When she was two she moved with her family away from the bombing, to the tranquillity of a small cottage near Kendal, where fields and woods surrounded them. As a child, Vivienne loved the country and as she grew older she began to go walking in the Lake District mountains. Her father, a keen amateur painter, encouraged his daughter's artistic talents. She worked with him in his commercial art studio, and also completed a Degree in Printed Textile Design at Manchester Polytechnic. Furthermore, under the inspiration of her parents, both amateur musicians, she took up the cello. In her spare time, she became a very keen mountaineer and also began to paint mountain landscapes. By the age of twenty-one she was elected a member of Lakes Artists' Society.

Her husband is also a keen mountaineer and they have three children, including twin boys who unfortunately were born profoundly deaf. Necessarily Vivienne's painting had to stop to enable her to devote all her time and energy to the boys' development. Just before their fifth birthday, they started as weekly boarders at a specialist school. This was a difficult period for Vivienne, having spent so much time with them. As solace during this emotional time, she began both to paint again and to play music. As compensation for the upheaval in family life, they tried to spend all their holidays in the mountains of Scotland, North Wales and Cumbria, plus one exciting visit to Norway, which also spurred on her mountain paintings.

While staying one night only at the Rifugio Bertone, high above Courmeyeur on the Italian side of Mont Blanc, I was fortunate to see a spectacular sunrise. I arose early to find a clear sky and, on reaching the vantage point above the hut, was rewarded with a wonderful sight of the first rays of the sun on the summit. **The next half hour was spent watching the snow, rock and ice emerge from the deep shadows of night.** The view was so entrancing that I had to force myself to descend for breakfast in the hut, and then set off walking to the next hut at 8.00am sharp; no time to sketch, but thanks to photography, happy to have good reference material to take home.

Back home in my studio, I set to work. After looking at the projected slides, I began preparing a small study/sketch, 20cm x 16cm. On this, I thought about the correct colours to use as well as the best tone values to do justice to the scene. Then I went ahead and drew the subject up large on thin paper, **this time improving the composition, drama and mystery**. For instance, the clear blue sky allowed no link vertically between mountain and sky; no softness or mystery either. I wanted to give an awareness of depth as the glacier dropped steeply down to the valley bottom, so the trees were moved to allow a glimpse of the glacier as it falls over the rock band.

Sketches are vital when developing compositions. In this case, Vivienne could see that the clear blue sky appeared divorced from the mountains, and that the line of trees in the foreground prevented the inclusion of the dynamic glacier fall beyond.

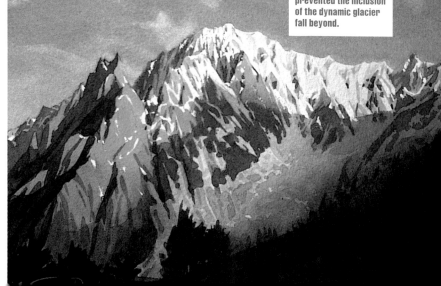

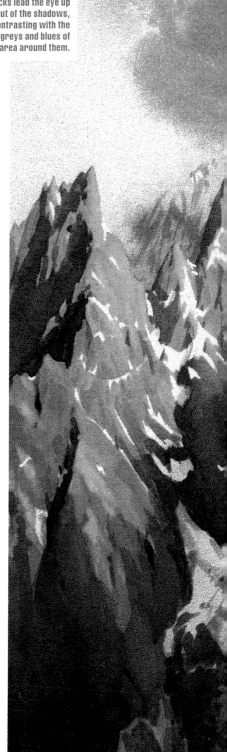

The warm earth colours of the sunlit rocks lead the eye up out of the shadows, contrasting with the cool greys and blues of the area around them.

acting

When all this had been considered, the elements of the drawing were traced faintly down on to a stretched piece of heavy-weight watercolour paper and painting commenced using a no.12 sable brush for nearly all the painting and a no.8 sable for small details. The sky was given a wash of slightly warm colour (Crimson Alizarine and Cadmium Yellow) followed quickly with the blue sky – a gradated wash using fairly strong Cobalt going to Cerulean at the mountain skyline. **While the original sky on the left was still wet, the warm greys of the cloud were put in adding cooler blue-greys behind the rock pinnacles.** When dry, the golden rocks were painted, descending through the richer earth colours to Indian Red and Winsor Violet in the shadows.

The following stage was the painting of the main shadow across the glacier and on to the mountain, with all the subtle variations in colour and tone. Once this was dry the shadow on the rock areas was painted over the top using the much darker/richer colours of the rocks. Several layers of colour were occasionally used to get the desired intensity. This was also the case with the depth of tone in the foreground trees, which required several layers of colour; one being a strong deep blue – French Ultramarine.

David Bellamy has the
reputation of being the
action man of the art
world. He is never
without a sketchbook,
however hairy the
terrain. Here, at the
Bossons Glacier, he
wanted to portray the
immensity of the glacier,
and the incredible shapes
formed by wind-sculpted
snow and ice.

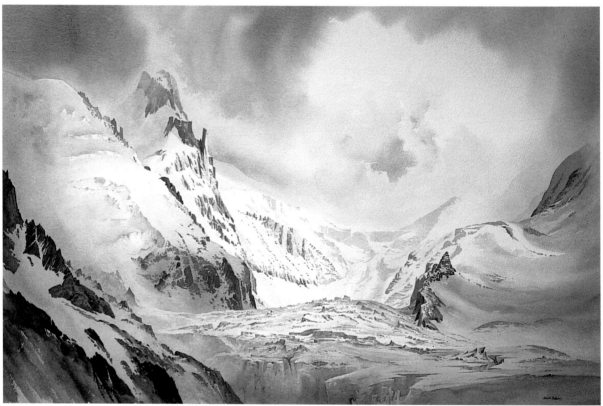

The Bossons Glacier
Watercolour on paper

The Bossons Glacier

Climbing mountains is my greatest passion, and of course, **I go nowhere without a sketchbook**. *It is surely true that if you paint what you love most, you are almost certain to do a better job of it! Snow and ice sculpted by the wind can take on amazing, and often inspirational shapes and images. Nowhere is this more so than on many of the glaciers, those great rivers of ice that most people stay well away from. As subject matter for a painting it is probably an acquired taste, but I believe that every artist should paint for him or herself now and then. Whilst this scene was sketched from terra firma in order to get a grand view of the scene, I also enjoy the more intimate compositions such as those of ice bridges, sometimes sketched from halfway down a crevice.* **Horror is not a necessary stimulus to inspiration, but it does seem to give a certain impetus to my work at times!**

David Bellamy specialises in painting mountain and wild coastal scenes, and is particularly fascinated by the moods of nature in wild places. His paintings have reached private collections in many parts of the world. A full-time artist and author, he has written and illustrated eight books. Wilderness Artist, his sixth book, picked up an award for excellence from the outdoor Writers' Guild, and his Watercolour Landscape Course became an art best-seller.

David travels widely in search of subjects; from the prairies of North America, to the deserts of Morocco; from the high Alps, to the Himalayas. Sometimes camping wild to catch the lighting at the best time of day, he makes a great effort to reach the right position to sketch. Trying to get that elusive sketch has led him into all sorts of problems, including falling over a crocodile in Kenya, and tumbling down a cliff amidst an avalanche of rocks and debris.

Through his painting and writing, he endeavours to bring about a greater awareness of the threats to the natural environment, and he is particularly active in conserving the wild areas. He is patron of the Marine Conservation Society's Seas for Life Appeal, and is an adviser to the International Society of Amateur Artists.

Clearing Mist, Cadair Idris
Watercolour on paper

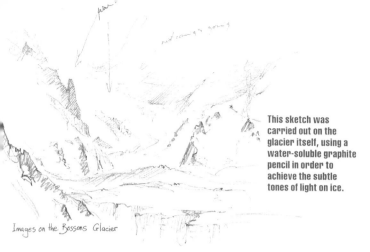

Images on the Bossons Glacier

This sketch was carried out on the glacier itself, using a water-soluble graphite pencil in order to achieve the subtle tones of light on ice.

seeing

*The Bossons Glacier lies in the shadow of Mont Blanc and I really wanted to portray an impression of the immense scale of the place, well aware that I could walk miles into this scene and the col at the far end would still appear just as far away as when I started. **It needed figures to provide a sense of scale, but these had to be invented**. Their smallness has not been exaggerated – a common technique used by Turner – as it was unnecessary in this, one of nature's grandest settings.*

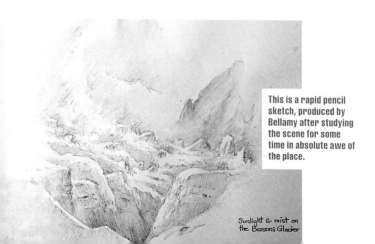

This is a rapid pencil sketch, produced by Bellamy after studying the scene for some time in absolute awe of the place.

Sunlight & mist on the Bossons Glacier

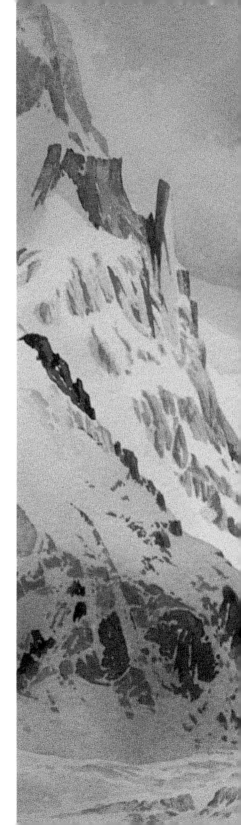

thinking

Palette for sky:
French Ultramarine
Davy's Grey
Naples Yellow

I began with the sky, excited by the interplay of light on the col, where clouds moved around creating a constantly changing backdrop. Mainly French Ultramarine was used, with some Davy's Grey here and there, with hints of Naples Yellow. The warm-coloured rocks were rendered with varying mixtures of Raw Sienna and Vermilion, and the shadow areas with washes of French Ultramarine and Cadmium Red. On the glacier itself, I reverted once more to mainly Davy's Grey, introducing hints of Cadmium Yellow Pale in places, and **constantly keeping in mind the need to retain the light on the horizontal surfaces of the ice**. Finally, the stronger dark rocks were put in with French Ultramarine and Burnt Umber.

Palette for glacier:
Davy's Grey
Cadmium Yellow Pale

Palette for rocks:
Raw Sienna
Vermilion
Cadmium Red
French Ultramarine
Burnt Umber

acting

The background area where sky meets mountain was made up with a series of very subtle overlaid washes to give the impression of the coming and going of images; in places light against dark, in others vice versa. **A damp brush was used in places to lose definite edges to create a lost and found effect**. On the glacier, I dropped lighter colours into the grey damp washes to relieve the stark greyness of an icy slab or abyss – after all, we all need some hope! Intermittently, warm light would penetrate the cloud layer and highlight crags, creating delightful contrasts to the overall gloom.

SOFTENING THE EDGES
With rocks surrounded in mist, edges appear and then gently disappear. A damp brush can be used over these areas to soften the definition and allow the edges to blend naturally into the atmosphere.

There is a realism about Rob Fairley's work that is achieved through his own impassioned relationship with the environment he paints. One can imagine actually being there at base camp with him, breathing the cold air, and being dazzled by the rising sun.

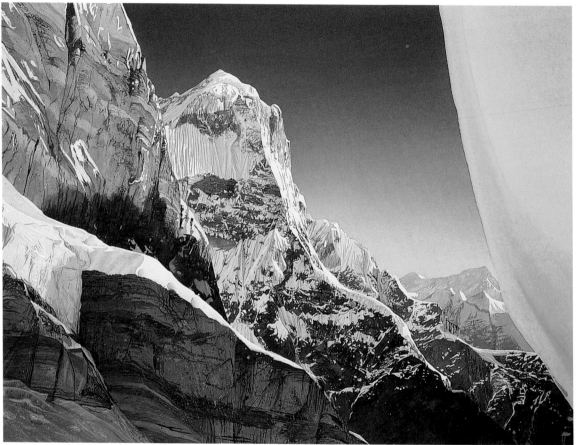

Breakfast with Henry
Watercolour on board

" *Breakfast with Henry*
For most of my working life, expeditions into the mountains have fed exhibitions, and exhibitions have (nearly!) funded further expeditions.

It is said that the Antarctic is a land that would prefer you to be dead. The high mountains are equally unforgiving, however, they do tolerate life, but do so strictly on the land's (or God's) terms. This, **the scale, and the deep frozen silence, are probably impossible to convey in a painting, but attempting to do so has become one of the pivotal leitmotifs in my life.**

A graduate of Edinburgh College of Art in 1974, Rob Fairley has been exhibiting in one-man and group shows ever since, including venues in Scotland, London and Moscow. An inveterate climber, his paintings often depict formidable mountain terrain, capturing, with incredible accuracy, the icy majesty of the world's most barren lands. Despite the isolation such paintings suggest, other subjects reveal the warmth of an artist fully involved with the people who inhabit the regions that so inspire his work. Sensitive portrait studies in materials that include egg tempera, oil, and even gold leaf, demonstrate the breadth of Fairley's work which also includes land art projects and collaborative pieces with various younger artists.

Fairley has undertaken many residencies including long associations with a couple of primary schools. A more recent project has involved Age Concern. Further afield, he is Fine Art Consultant at Kathmandu University.

Fairley is a firm believer that art should not be competitive, and as a result, has not entered competitions and turns down awards made through 'open' exhibitions.

His work has been widely published, and is held in private collections quite literally in every corner of the world.

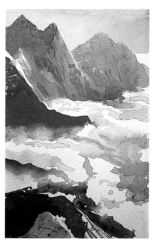 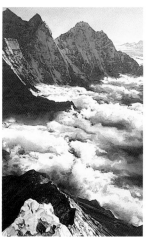

Although the original sketch for 'Breakfast with Henry' is lost, this sketch for 'The Walk to Namche Bazaar' was done in a very similar manner, once again with the paint freezing to the paper before it dried. It was done on the south west ridge of Ama Dablam.

The Walk to Namche Bazaar
Watercolour on board

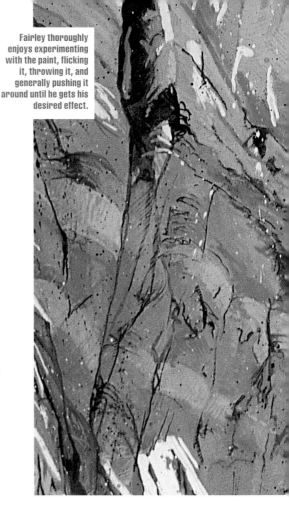

Fairley thoroughly enjoys experimenting with the paint, flicking it, throwing it, and generally pushing it around until he gets his desired effect.

seeing

The original sketch for 'Breakfast with Henry' was produced while exploring the ridge between the south and true summit of Kasson Kangaroo, an elegant and technically awkward mountain that sits between the Khumbu and Hinku valleys in Nepal. We were a small group climbing in two lightweight, independent, but mutually supportive teams. One team had returned from the South summit very late the previous evening and Henry and I had prepared hot drinks and a meal for them. We expected breakfast in return and when this was not forthcoming, Henry was not best pleased. **To avoid the 'discussion', I grabbed my sketchbook and stuck my head out of the tent. The paint froze to the paper before drying and I had to start the stove to melt and dry it.** The sound of the stove destroyed the silence, resolved the breakfast debate and started the climbing day.

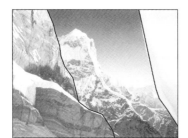

Fairley has used the age old triptych structure as a device to give form and balance to a startlingly modern painting.

thinking

I made my original sketch, (unfortunately now lost), in pure watercolour, however, the final painting is technically quite complex (a bit like the mountain really!). **I have always been intrigued by the format of the triptych and the inevitable philosophical resonance its use produces.** This was a chance to paint a landscape triptych in one piece. The entire painting was completed initially in monochrome, using diluted washes of black ink. The sky at the top of the page was almost pure black with the only white board left untouched being the tent flap on the right and any point where the sun was shining on snow. These white areas were then masked off before colour was added.

ROB FAIRLEY'S
UNDER-PAINTING TECHNIQUE

The technique, which is similar to early watercolour techniques, derives from tempera painting. The tonal values are established by an under-painting and the transparent colour is applied thinly so as to maximise the optical qualities of paint and paper. It allows the unusual mix of very free painting with a result that is undoubtedly 'realist'.

acting

The sky went in first: a wash of Cobalt Blue with a touch of Ultramarine swatted on to the board with a 6" house painter's brush. The colour was battered around until it looked right and then the process was repeated ad nauseam until it not only looked right, but felt right as well. **All the tonal values exist in the monochrome under-painting so the washes of colour are very thin**. The result is a very transparent feel to the sky. When this was dry, I painted in the distant mountains. These were also handled much more freely than first impressions suggest; multi-layered interweaving washes producing a look of realism. The painting then proceeded from back to front; **I have always thought it sensible to apply paint in the same order as the object depicted sits in space**. With this in mind, the central panel of the triptych was therefore completed before the cliff face on the left was started, and the orange tent flap (the right-hand triptych wing), was put in last.

The cliff face was fun to paint – everything else on the painting was masked off with newspaper and the paint was flicked, thrown, dropped and then generally thumped around until the desired effect was achieved. A thin wash of Cadmium Orange on the remaining white right-hand 'panel' nearly completed the painting; the final touches being carried out with a large house painter's brush loaded with White Gouache. The sky and tent flap were masked off for a final time, and the brush was flicked over the surface of the board to produce thin lines of paint which simulate light catching the snow.

" Painting is a constant search to try and find the universal within the specific. A painting is by its very nature a window, and I like the feeling of looking through, of glimpsing for that briefest moment the image, the essence of the thing. My work has always been rooted in the abstract compositional possibilities found in nature – the patterns in the sand, the shapes in the rocks, the colour harmonies in the sky and clouds – these interest me more than a literal description of objects.

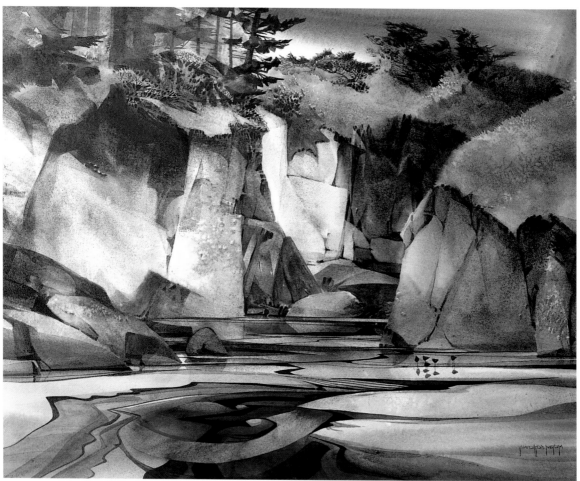

Harts Cove
Watercolour on paper

"

Harts Cove

I grew up on the rugged Oregon coast and have always been attracted to the rocky interface between the land and the sea. Most of my coastal landscapes relate to the theme of interplay between sea, sand and rock. 'Harts Cove' is one of this series. **My work has always been rooted in the abstract compositional possibilities found in nature.** *I'm not interested in the physical landscape 'per se', but in its essence. The pattern in the sand, the shapes in the rocks, the colour harmonies in the sky and clouds: these interest me more than a literal description of objects. I try to capture the emotional and visual excitement I feel while walking along the coastline, exploring the shore architecture.*

Michael Schlicting is one of Northwest America's most outstanding watercolour and acrylic artists. His dramatic compositions are characterised by vibrant colour and unique textural layering.

He received his BA in Fine Arts from Principia College in Elsah, Illinois in 1976, and has won awards at both the American Watercolour and National Watercolour Societies' annual exhibitions in addition to an impressive number at other state and regional shows. He was elected to the AWS in 1990 and has been a National Vice-President. Michael has juried exhibitions and taught workshops across western and middle USA , as well as in Italy and France. His paintings are held in many public and corporate collections, including the Intel Corporation, Portland, Oregon, the US National Bank of Oregon, and the Alaska State Council on the Arts.

He lives in Portland, Oregon with his family while maintaining a summer studio/gallery on the central Oregon coast.

Cormorant Rock
Watercolour on paper

Cascade Head
Watercolour on paper

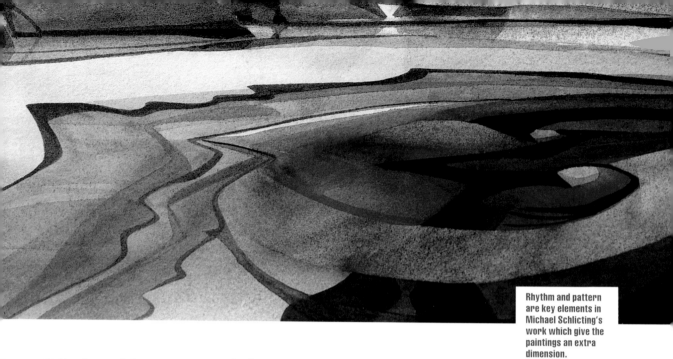

Rhythm and pattern are key elements in Michael Schlicting's work which give the paintings an extra dimension.

I started the painting process by doing thumbnail tonal studies. This gave me a rough idea of the overall composition. I look first for a couple of strong geometric shapes to anchor the design and then start playing off those elements with a series of rhythmic linear shapes. Once the general composition is going, **I let the rhythm of the patterns dictate the direction of the painting**. I try and build the picture intuitively as that is where I find satisfaction in the painting process.

I try to approach many of my paintings in a sculptural, tactile way. To keep interested in my painting as I'm working on it, I strive for resolution and strong design at six inches, as well as having it read well from across the room. **I like to use a strong tonal pattern in my work, and prefer to err on the side of being too strong** as opposed to painting weak washed-out paintings. I don't think of myself as a colourist in the sense that I have a specific colour theory that I follow. My approach is quite intuitive relying more on a sense of the 'right' colour as much as anything else. I can only analyse the results.

acting

*Working on a sheet of 300lb. Arches' cold-press paper, I started painting wet-into-wet with large washes of fairly heavy saturated pigment. One way I create shapes that is a bit out of the ordinary, is to lift out colour with sponges and templates. To facilitate this I tend to use sedimentary colours. Cerulean Blue is a favourite along with Burnt Sienna and the Ochres. After the initial paint application is dry I start lifting out shapes with a clean damp sponge. I use stiff mylar cut into various shapes as templates for the lifting. I create shapes and tonal changes by this method. It lends a complexity and interesting textural development to the painting that isn't really possible through other methods. I repeat this process several times in the course of completing the piece. **The process of painting is what I enjoy – intuitiveness, the physicality of the paint**, and not worrying about the means to achieve my goals!*

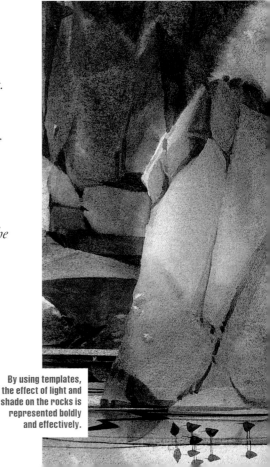

By using templates, the effect of light and shade on the rocks is represented boldly and effectively.

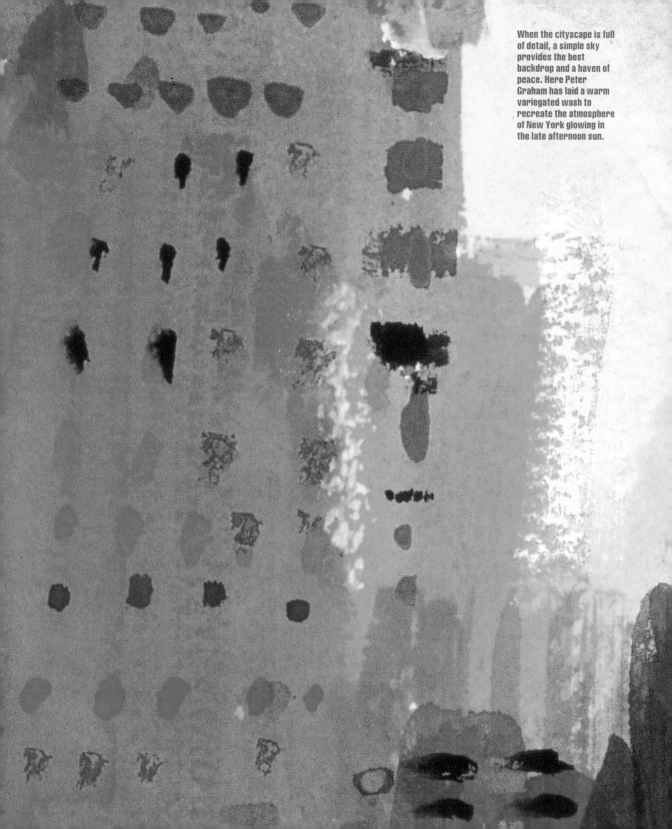

When the cityscape is full of detail, a simple sky provides the best backdrop and a haven of peace. Here Peter Graham has laid a warm variegated wash to recreate the atmosphere of New York glowing in the late afternoon sun.

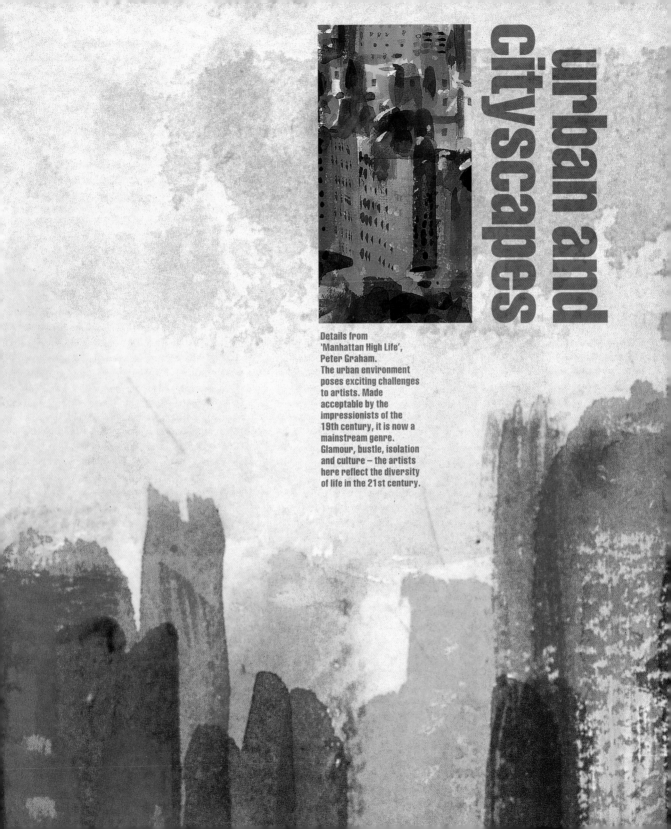

urban and cityscapes

Details from
'Manhattan High Life',
Peter Graham.
The urban environment
poses exciting challenges
to artists. Made
acceptable by the
impressionists of the
19th century, it is now a
mainstream genre.
Glamour, bustle, isolation
and culture – the artists
here reflect the diversity
of life in the 21st century.

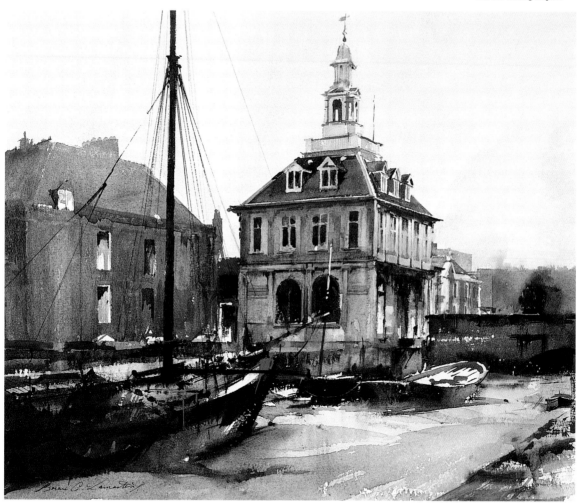

The Old Customs House, King's Lynn
Watercolour on paper

" *The Old Customs House, King's Lynn*
While not travelling as much as I used to, I find I do have to travel to find subjects, as I am very selective. This is personal, of course, and many artists may find lots of interesting subjects that involve little travelling. Although now living in the west of England, I have probably got more subjects from the East Anglian region than any other. **I find the big open skies of East Anglia inspirational.**

Originally from Atherton, near Manchester, where he was born in 1931, Brian Lancaster worked as a graphic designer in Canada for several years. He then returned to England, where he settled in the Bristol area, working as a designer and illustrator. He became an Elected Member of the Bristol Savages in 1969, and a Member of the Guild of Railway Artists and the Royal Society of Marine Artists in 1990 and 1997 respectively. He was also made a Fellow of the Royal Society of Arts in 1995.

His watercolours have appeared in numerous publications and can be found in the Bristol Savages Permanent Collection, Bristol City Museum, and the collections of the Duke and Duchess of Beaufort at Badminton House, Sir William McAlpine, Sir William Halcrow and Singer & Friedlander Ltd. He has been included in Who's Who in Art since 1988.

Ancient Alleyway, Old Newcastle
Watercolour on paper

SS Cormorant in Scottish Waters

Although the building needed to be drawn accurately, it was not necessary to depict every minute detail. Some features can be simply suggested. This maintains the energy of a painting rather than letting it move into the realm of architectural illustration or photographic realism.

seeing

I had known King's Lynn for some time and although the scene depicted is kind of 'conservation area-ish', it has been done very carefully and unselfconsciously. It had all the ingredients that interested me. Architecture has been an interest of mine since art school days, and for some reason I respond to the 17th-century styles as opposed to the 18th-century Georgian, which I find pretty boring. So, with the combination of the old ships moored alongside, this fine building was all I could wish for.

The lovely lines of the old building needed to be accurately drawn with the proportions correct, but some details can be simply suggested, *otherwise it can become an architectural illustration rather than a painting. One tries to keep the unity throughout the picture so that nothing 'jumps out'. I hope that I handled it about right, taking great care to capture the light catching the right-hand side of the structure.*

*The weather was not very bright, but reasonably light. This helped cast highlights on the wet mud, which I painted very directly, taking care to leave the light areas and rivulets to give the whole of this area interest. It is most important to observe this aspect of all paintings, and it is as important as buildings, boats, etc. The key thing with the boats is the way the light picks up on a section of the decks with an occasional highlight here and there. **It is absolutely essential to leave these clear of colour (i.e. the white of the paper) so one has to work relatively quickly,** but pay great attention to this.*

*For the foreground boat and the building, I put in broad washes, and once again I didn't want the eye to be distracted unduly away from the main object. Note the different colours and textures blended in on quite a big area of wall. If this had been done as a flat wash, it would have been pretty uninteresting. **Observing all the fluctuations caused by the weathering of old structures is very important**, wherever possible the windows are left white – I rarely use masking fluid, though there are exceptions. For finer window sashes, etc., I use White Gouache, as painting round these is a chore and destroys the flow if one is a fairly fast painter.*

Mundane though it might be, the area of wet mud is important, leading the eye into the image towards the building. It also acts as a dynamic space, enlivened by rivulets that break up the surface and reflect the light, forming some of the brightest highlights within the painting.

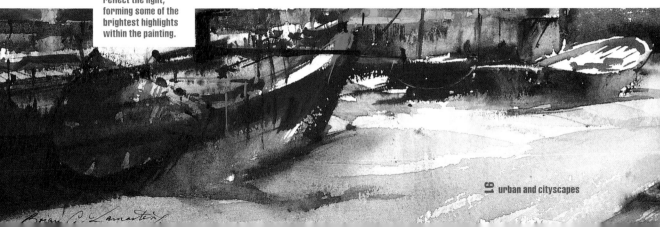

December Docklands

This painting is unusual for me as it represents a period that was long before my time, and consequently had to be composed out of my head. I think I have only ever done two paintings based on historical scenes out of all the many hundreds I have carried out over the years. Having said that, quite a lot of my subjects are based on photographs, particularly shipping subjects, as the graceful lines once seen seem now to have been replaced by computer-designed ships!

I was born and brought up in an industrial area, which I actually enjoyed as I commenced drawing and painting at an early age. **The misty light, filtered through a smoky haze, seems to have been with me all my life.** *Somehow I responded to it, and still do wherever it can be found. I consider myself to be an 'atmosphere' artist, which of course can cover a wide range of subjects.*

With this painting, which was quite a quick sketch, I wanted to convey the feel of the era, somewhere around 1900. **Many younger artists painting today have never experienced the way things were and consequently paint everything too clean.** *The atmosphere in which I grew up in the late '30s and early '40s had changed little during the early years of the century – therefore I felt able to capture the feel of the period. The ships such as the ones depicted had almost all gone by the '40s, with the exception of a few commercial square-riggers, but since I had a reasonable knowledge of late 19th-century steam and sail, it was not a problem to achieve an authentic look.*

I was particularly interested in the contrasting types of vessels to be found in the docklands of those days, and **tried to recreate the general hustle and bustle of the docklands with their interesting silhouetted skyline.** *A major part of the scene was the lighters (barges) that conveyed many of the goods from the ships. A group of these are moored on the right with the vague, filtered light catching their covered awnings. This was all part of the fabric of commerce of the day, and is what I find stimulating, which is, of course, an essential ingredient in producing a painting.*

The atmospheric light created by the vapours of industrial waste has attracted painters since the dawn of the industrial revolution.

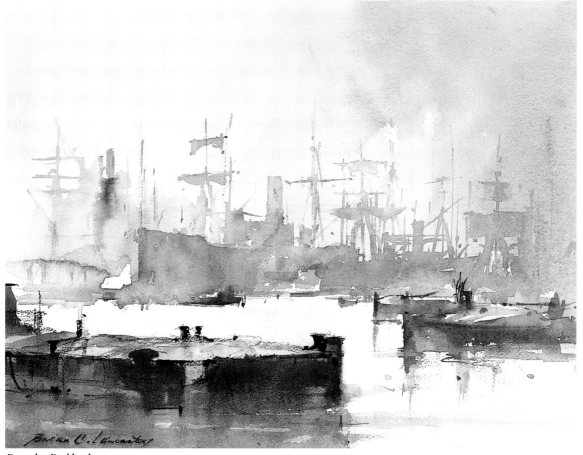

December Docklands
Watercolour on paper

"As the painting is mainly done in grey hues, I thought I would introduce a little colour in the two brown topsails (which had probably been left unfurled to dry) and in the vague wintry glow in the sky, to suggest a hidden sun. The quality of the greys is very important and they are made from various combinations of colours which I often arrive at by chance! Quite a good combination is light red and one of the blues, preferably (for me) Cerulean. The best thing is to experiment using combinations of opposites.

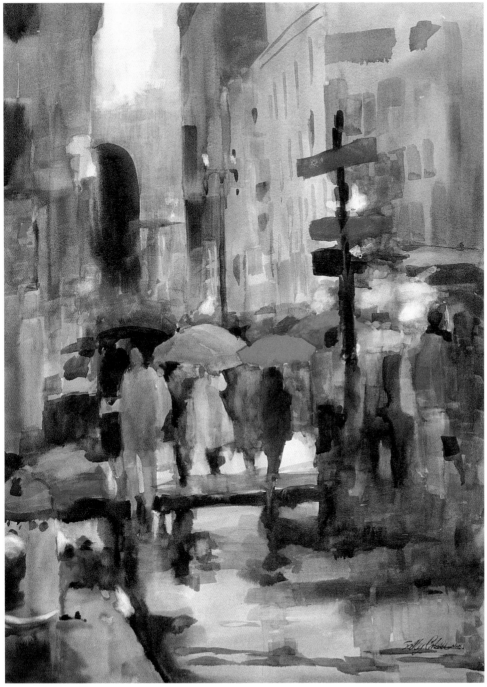

The bustling streets of San Francisco one particularly wet evening provided stunning material for a watercolour. Glowing colour emanates from the artificial light, ever shifting humanity contrasts with solid geometric architecture, and there is, of course, the fantastic carpet of shimmering reflected light below.

Union Square
Watercolour on paper

Sally Cataldo loves the fluid and luminous quality watercolour offers, and uses the medium to express her feelings about a place or moment in time. She describes her art as her 'visual personal expression of her journey through life'. Born in Modesto, California, in 1953, she has led numerous workshops, frequently alongside key American artists, including Arne Westerman, Charles Reid, and Judi Betts. Her work has won many awards including recognition at the American Watercolour Society, and the President's Award at the 1996 California Watercolour Association.

"

Union Square

The inspiration for 'Union Square' and 'California Street, San Francisco' came one year when we had an excessive amount of rain. Everywhere it was flooding. **My surroundings had a deep impact on my paintings.**

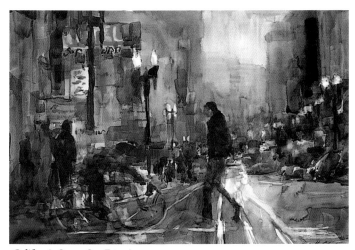

California Street, San Francisco
Watercolour on paper

kandinsky

Colour is a power which directly influences the soul. Colour is the keyboard, the eyes are the hammers, the soul is the piano with the strings. The artist is the hand which plays, touching one key or another, to cause vibrations in the soul.

I was in San Francisco walking around Union Square in the rain. I took some pictures on my 35mm camera. It was about dusk and the light was just about gone. **My photographs came back blurred and dark, leaving only images of figures and buildings, with reflections of light and colour.** In my mind I could visualise what I was after, and I wanted to illuminate the background and enhance the colours to achieve the effect I wanted.

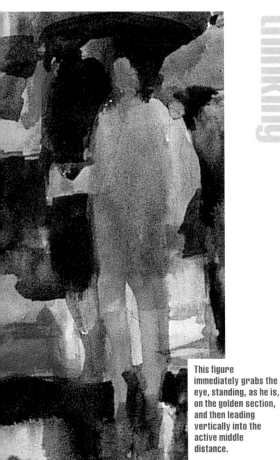

This figure immediately grabs the eye, standing, as he is, on the golden section, and then leading vertically into the active middle distance.

My sketching worked best vertically to show the size of the city cast in limited light. The large shape in the foreground made for an easy entry into the painting, leading to the figures and umbrellas. The lamppost gave unity in connection to the buildings. **Adding the curved lines of the umbrellas gave the drawing an organic shape that contrasted nicely with the geometry of the city buildings.**

At the time I was studying Rothko's paintings. With this inspiration I was working on colour harmony, how colours look side by side, and lost and found edges. I was also working on breaking the space of the rectangle in an interesting way, and using mostly middle-to-dark values to create the feel of mood and winter. I used vertical dominance, with horizontals to contrast with curvilinear colours, and the people for the focus of the painting. **Where one figure reads to the eye as vertical, rows of figures read as horizontal, working as a contrast to the vertical of the paper and the buildings.** The umbrellas add the curvilinear shapes which, through colour and shape, also contrast with the vertical. The sky is an important part of the painting as a release for the eye. It feels good to me to have an outlet because it makes me feel that there is more out there. You don't get boxed in – you're not confined.

Inspired by Rothko, abstract shapes and the juxtaposition of rich colours, magnificently create the illusion of flooded streets.

ROTHKO'S INFLUENCE

In the 1940s Mark Rothko gradually moved from figurative work into more symbolic representations. By the late 1940s, figurative references had disappeared altogether as he developed a form of abstraction based on the relationships between line, colour and form. These Multiform works as they became known, with their asymmetrically arranged blocks of colour, prefigured the sparser and better-known works that followed. In both types of work he used liquid paint in such a way that it soaked into the canvas, creating soft, indistinct edges. Using watercolour, Cataldo was inspired by Rothko's approach to explore a similar use of colour patches, creating dynamic compositions and colour harmonies. Colours and shapes merged and abutted through the use of lost and found edges. Although working figuratively, there remains a bold, abstract quality to her paintings.

acting

I started by sketching the scene out, very loosely, on the paper with a 4B pencil. The essential lines for placement came next, just to show me my layout with no details. I then added a light wash for the sky and went in right away to add the buildings with more pigment and darker values. I added the closer building with a few select windows to suggest perspective. I then worked towards the street where I started adding more colour and darker values. **Next, I bounced back and forth between the figures and the street adding negative and positive shapes to create more contrast and excitement.** *When the painting was done, I wasn't pleased. I therefore made a wash of a warm blue and a warm red to add to the already dried painting. I softened edges and added an overall darker value. I also lifted out some areas in the reflections using my one-and-a-half-inch square brush with water, and then added darker shapes in pure thick paint, particularly in the umbrellas and other areas to illuminate their colour.*

No. 9, 1948, by Mark Rothko
Oil and mixed media on canvas
135cm x 118cm

Gift of The Mark Rothko Foundation, Inc.,
Photography (c) 2001 Board of Trustees, National
Gallery of Art, Washington

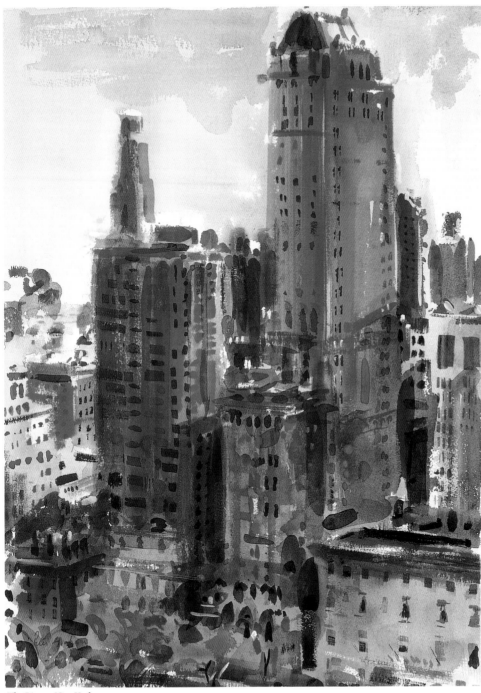

Peter Graham captures the bustle and excitement of life in New York vividly in this painting. The dazzling Pierre Hotel dominates the composition as it does in reality; a sophisticated landmark full of history and colour.

The Pierre, New York
Watercolour on paper

"

The Pierre, New York

Painting from an apartment overlooking Central Park in Manhattan, **I found the imposing art deco architecture in New York a great source of inspiration.** *Walk up between The Park Lane Hotel, past The New York Plaza, then on to Fifth Avenue and there is the infamous Pierre Hotel, towering above on your right, sandwiched either side by The Knickerbocker Club and The Metropolitan Club.*

Manhattan High Life

Looking out from the 31st floor of The Park Lane Hotel on Central Park South, **I watched sunrise over Manhattan's golden shadows gradually reveal the dazzling reflections of the city of New York.** *Using large Raphael and Daler Rowney mops, I created a warm-toned ground with Cadmium Yellow, Gold Ochre and Raw Sienna to convey the sensation of the sunrise over the Manhattan skyline with its brilliant reflections from the glass of the buildings.*

A graduate of the celebrated Glasgow School of Art, Peter Graham has fast gained the reputation of being one of the UK's most gifted colourists and features regularly in key arts publications. Graham worked initially for the BBC as a film editor, but in 1986 turned to painting full time. Careful detail combined with fluid brushwork reminiscent of the liveliest of the impressionists, create a dynamic exuberance that is all his own. Each year Graham spends the summer painting in the French Riviera. Scintillating beach scenes and harbours are key subjects in his oeuvre, but he is also renowned for his equally vibrant still lifes. In 2001 he was elected to Full Membership of The Royal Institute of Oil Painters. His work is held in a number of private and corporate collections both in the UK and in Singapore where he held a three-month residency at the Nanyang Academy of Fine Arts.

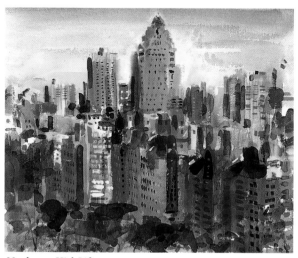

Manhattan High Life
Watercolour on paper

Studying the strong sun glinting on the skyscrapers, I felt humbled in the presence of such an achievement. New York is indeed a majestic city, perched on a tiny island in the middle of the Hudson River. As an artist, experiencing these wide open tree-lined avenues, watching billowing steam ascending from the rooftops and sidewalk grills, the hot dogs and pretzels – **the creative thrust of this place has just got to be captured in paint**. *How to express this feeling on paper is a monumental challenge.*

Speed is vital when trying to capture fleeting light. Rapidly applied dabs of vibrant colour are the secret to Graham's sparkling images.

When you go out to paint, try to forget what objects you have before you, a tree, a house, a field or whatever. Merely think here is a little square of blue, here an oblong of pink, here a streak of yellow, and paint it just as it looks to you, the exact colour and shape, until it gives your own naïve impression of the scene before you.

Colour feeds the imagination**. Whether using it to describe the facades of buildings or recreating the reflections from a hundred windows,* ***it can emotionally charge the work. *My colourist style relates to the impressionist approach with an emphasis on vibrant tones and hues when applying the paint. The impressionists used dabs of paint as opposed to blending tone.*

Graham can be described as a modern impressionist. His style relates to the 19th-century artists who discovered they could create a more dynamic surface by allowing colours to mix in the eye rather than on the palette. They achieved this by juxtaposing dabs of pure colour that at a distance would appear to blend. The transient effects of light, and colour itself, were the impressionists' subject matter, epitomised in Monet's sumptuous works.

acting

Working on Arches' 400lb. (850gms) rough paper, I tried to keep the painting moving with energetic strokes and broken colour. My impressionist style is about capturing the light, so by necessity, my work was completed rapidly, with shorthand techniques adopted to describe the thousands of windows and many facades. I used large sable brushes (no.10 or 12), both flat and round, fan brushes, and mops. A two-inch synthetic flat brush created the vertical tram lines on the Pierre Hotel.

The painting was completed on the spot with much attention paid to sunlight and shade to create mood. *I used the minimum amount of detail so as not to distract from the impression of distance and scale. Instead I concentrated on the reflected light from the many planes and facets of the buildings.*

Rouen Cathedral, 1891
by Claude Monet 1840–1926

Christie's Images, London, UK/Bridgeman Art Library, (c) ADAGP, Paris and DACS, London 2001

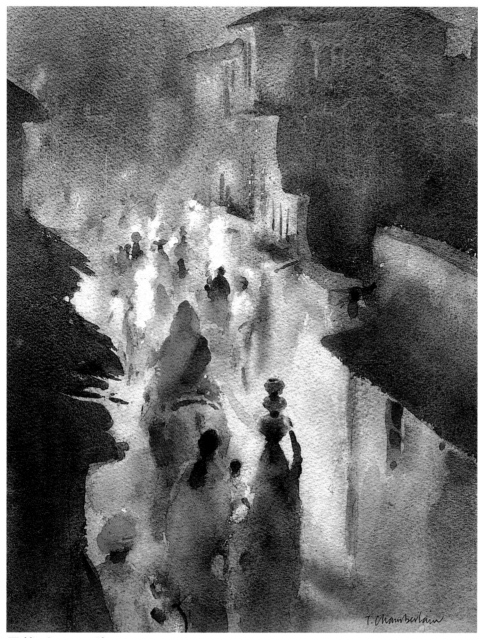

A dramatic explosion of colour, movement and noise shattered the peace of a stay in Ghanerao. Too dark to paint, but too exciting to let pass, Trevor Chamberlain used photos, sketches and the imprint on his memory to create this atmospheric and celebratory image.

Wedding Procession, Ghanerao
Watercolour on paper

Art is not what you see, but what you make others see.

Wedding Procession, Ghanerao

During our stay in Ghanerao, a large village in Rajasthan, my painter colleague and I were allocated a simple bedroom on the roof of the Royal Castle, which was a contrast to the relative comfort enjoyed by the other artists on the trip who were accommodated below within the building. However, in our 'eagle's nest' it was a joy to savour the quietness, hearing only occasional distant voices, the moo of a cow, or the periodic tolling of a bell from the local Jain Temple. Vehicle sounds too, were a rarity. **This idyll was suddenly shattered on our second day! Loud, garish music pierced the air and continued on and off, for nearly three days and nights. It was a build-up to a forthcoming Hindu wedding, when the bride is traditionally paraded through the streets riding on horseback,** *attended by a large retinue of family, friends, well-wishers and their children. Accompanying this huge procession was the source of all the noise. It was a decorated pram carrying a primitive amplifier with loudspeakers, supported by three or four people, trumpets and the like, all happily blaring away.*

At night the procession was lit by several hand-held clusters of electric lamps — **the sight was so dramatic that I had to paint it, somehow.** *Luckily our roof overlooked one of the routes being continually used by the wedding party. It was too dark to do any work directly on site, but I had several opportunities to observe and absorb the subject seen through the shifting effects of the light clusters.*

A self-taught artist, born in 1933, Trevor Chamberlain first worked as an architectural assistant before becoming a professional painter, specialising in marine, figure, town and landscape subjects. His highly acclaimed work is concerned primarily with atmosphere and light, achieved through working 'en plein air'.

Chamberlain is a member of the Royal Oil Institute and the Royal Society of Marine Artists, and President of the Wapping Group of Artists. His work appears regularly at the Royal Academy, and over the years he has won many awards. These include the Lord Mayor of London's Award, five ROI Exhibition awards, the Chris Beetles Award at the Royal Watercolour Society, and the Laing Painting Competition. Examples of his paintings can be found in a number of public galleries and a variety of prestigious private collections.

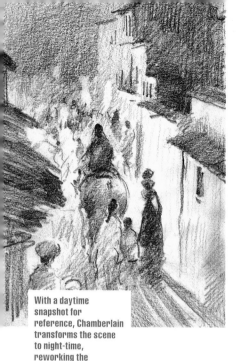

With a daytime snapshot for reference, Chamberlain transforms the scene to night-time, reworking the composition, changing the tonal values.

I decided that I could only produce a painting back home in the studio, so I took a photograph when they passed by in the daylight. **My next stage was to do a quick pencil sketch to transform it to a night situation working out the composition and tonal relationships.** Together with the photograph and the image, so impressed on my mind, it was enough for me to produce something striking to give the moving, diffused effect I wanted.

I decided to use watercolours, selecting a fairly rough 140lb. weight paper, which I stretched. **Having pencilled in the subject I applied masking fluid to preserve the white paper on the areas of the light clusters.** I used my usual palette of colours for mixing: Raw Sienna, Burnt Sienna, Venetian Red, Permanent Magenta, Ultramarine, Sepia and touches of Cadmium Yellow, Red, and Orange, Olive Green and Terra Verte.

Chamberlain's palette is restricted, but his skilful mixing creates a range of subtle, atmospheric blends:
Raw Sienna
Burnt Sienna
Venetian Red
Permanent Magenta
Ultramarine
Sepia

The whole sheet was dampened with a sponge and I then proceeded to paint wet-in-wet, working from light to dark, covering the complete area. When it dried, I rubbed off the masking fluid, and then applied a second application of paint, still working fluidly, but more accurately. In fact **I was drawing with the paintbrush, enhancing the atmosphere with contrasting lights and darks.** I re-assessed it the next day, making minor adjustments — **lifting out the pigment slightly here, adding a colour or dark accent there, generally resolving and unifying the image**.

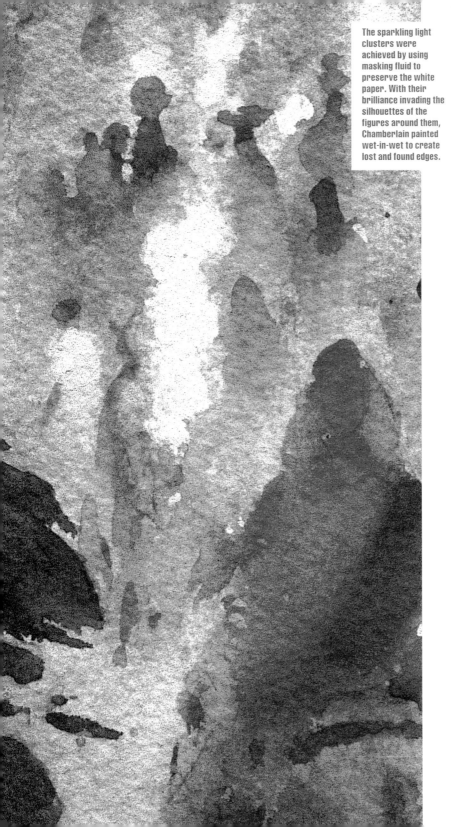

The sparkling light clusters were achieved by using masking fluid to preserve the white paper. With their brilliance invading the silhouettes of the figures around them, Chamberlain painted wet-in-wet to create lost and found edges.

USING MASKING FLUID

Masking fluid is invaluable for retaining whites. Using an old brush, it can be painted on to the areas you wish to preserve. Once dry, you can paint over it as freely as you wish. Rub the fluid off when the paint is completely dry, revealing the untouched paper beneath.

WORKING WET-IN-WET

Chamberlain dampened the whole paper, and then dropped colour in, creating a softly blended, dynamic surface. Similar effects can also be achieved by dropping colour into other colours that have yet to dry, letting them bleed together and form exciting shapes and combinations.

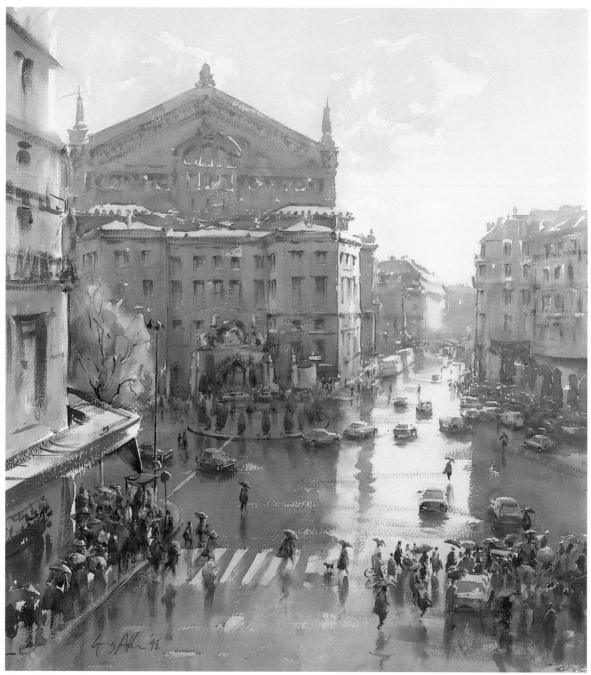

Place de L'Opera, Paris
Watercolour on paper

Wet roads provide wonderful visual effects. Capitalising on a winter shower at rush hour, this image of Garnier's Opera House comes alive as figures and vehicles appear to float on a shimmering surface.

Greg Allen has developed a considerable reputation as one of Australia's most accomplished watercolourists. Born in Melbourne, Australia in 1958, Allen initially studied graphic design and illustration before becoming a professional painter at the age of 23. He cites Australian artists Harold Herbert (1891–1945) and Arthur Streeton (1867–1943), along with John Singer Sargent (1856–1925) as inspiration behind his strong, fluid, yet richly-toned work, which is diverse in its subject matter. From the inception of his career, he has received numerous and important awards, including the Camberwell Rotary Travel Scholarship, and both the Camberwell Rotary Watercolour prize and the Alice Bale Watercolour prize on more than one occasion. Although watercolour is his main medium, he also paints in oil and pastel. He has featured in Australian Artist and International Artist magazines, amongst others, and is a member of the Watercolour Society of Victoria and the Victorian Artists' Society. He exhibits regularly in Melbourne, and his work is held in city, corporate, and private collections across Australia.

"

Place de L'Opera, Paris

I can remember many things painting 'en plein air' in Paris in December of 1998, the period that produced these images. Super-cooled fingers for one thing, for this was 'le refrigerated plein air'! I remember, too, my phosphorescent trail of Cadmium Orange weaving a serpentine emergency lane throughout the Paris streets (it never seemed to solidify!); on-the-spot watercolours that dried, oh, by sometime the next day; and the wide berth and narrow-eyed disdain often practiced by the passers-by on those freezing cold days, that I guess anybody would give to someone clearly displaying the credentials of 'silly nutter'.

*Not exactly ideal conditions for aquarelle you might think. But **I had a plan; a desire to push a little more and violate a comfort zone or two.** I was here on a serious three-month sojourn to Europe from Australia for painting only. Solo. One up. Lightweight and able to be spontaneously itinerant; exploiting the off-season and deliberately looking for different ideas, (I'd been before, but in high seasons and for shorter durations). I went to less obvious countries like Malta and Poland, **painting whenever an idea materialised, particularly in twilight and even in steady nocturnal conditions while perched under street lamps.** I ventured into cafes and bars to sketch and record. Painting moods; painting wet streets; painting the peopled places of the night. Straining to see anew.*

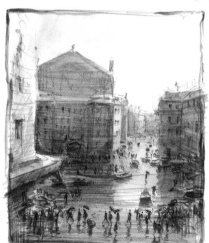

I have grown to relish the painting of rain and its effects, especially in cities and towns while it lingers on roads, parks and footpaths. What I particularly love is how it can transform a foreground, while offering unique design possibilities. In a way it's somewhat analogous to the ordered symmetry and beauty of a mirrored surface such as a lake. **Plain old asphalt suddenly becomes quite interesting, as do the dancing umbrellas and the nebulous reflections of buildings, as they flip themselves down into the ground.** The city streets take on a 'floating' look, just as they are in Venice where the reflective ability of the canals is half the key to the pictorial success of almost every painting anyone has ever done there!

Paris has many intimate facets, but it is also about grandeur, scale and presence – all eloquently personified in her architectural icons – and I longed to do something grand! Garnier's Opera building was one icon I kept bumping into and it epitomised modern Paris with its wealth and culture. It was a cluttered visual cacophony at street level, but **it is always worth raising oneself, especially when there are other buildings and windows from which to gain a different, higher perspective.** Eventually I sketched some ideas from an elevated department store walkway that brought out the Opera House's true splendour.

What developed was a strong simple design that promoted a silhouette, while allowing a journey for the eye down another major street. But the whole scene looked all the more wonderful and alive in rain at peak hour! With the street 'afloat' I could emphasise the 'contre-jour' atmosphere and flip the light passage down into the lower right corner, offering a balance to the dark skyward penetration of the Opera House.

Fear abates in the doing, so after a couple of hours of 2B pencil work, I began with the sky. **I always try to simplify the painting of various subjects by regarding them simply as forms in light** *and link this in with the general idea of painting watercolours from light to dark.*

The lightest element in most scenes or at least most daytime outdoor material is the sky – the source of light itself. I call this the horizontal 'ceiling' of the world and generally paint this first. It follows that the most obvious beneficiary of that light will be the ground plane – the 'floor' of the earth. I paint it next, for irrespective of its local colourings, be they grasses, sand, rock – and in this instance, shiny asphalt – it will still generally be the next lightest value.

The other horizontally oriented elements usually constitute the main shapes, forms and masses of the core subject matter – perhaps a mountain with trees and barn, or in this example the Opera House itself. I paint the upper surfaces of these elements next. Of course, painting these upper surfaces might occasionally involve only the preservation of some white paper, if strong sunlight is acting on them. At this stage, most or all of my horizontal light-affected areas are painted in with their correct colours and values, having tested each one on a separate piece of paper before application. **My whole paper surface is now covered in bands of tones, some blending into one another.**

What's next are simply my verticals, tonally advancing from the distance where they will be of slightly lighter value, right up to the closest, darkest verticals such as fences, poles, cattle, people, cars, etc. By verticals I mean the sides of things relatively unaffected by direct light – the sides of mountains, sides of middle distance trees, sides of barns, etc. In 'Place de L'Opera' it is the painting of the sides of principal buildings that came next, followed by their reflections, then finally the cars and foreground pedestrians.

Large mop brushes were employed for all major masses, and colours restricted to pale Cobalt Blue for sky and mixtures of French Ultramarine, and Burnt and Raw Sienna for most of the walls of buildings.

As the biggest watercolour painting I had ever done, it was a risky, scary exercise, but one that paid off.

Large mop brushes were employed for all the major masses, and the colours were restricted to blues and earths:
Pale Cobalt Blue
French Ultramarine
Burnt Sienna
Raw Sienna

GETTING THE COMPOSITION RIGHT
Numerous sketches explored the
optimum placement of the birds,
drawing them into social and visual
balance against the reflected elements
around them.

" *A Congregation, Notre Dame, Paris*
Many of the cities of the calibre of Paris, Rome and Venice have
so many iconic buildings and landmarks – and their own
special ambience – that painting with any real originality becomes
quite difficult. **So many artists have done such magnificent**
interpretations of what is to be painted that it's easy to feel
either inadequate and overwhelmed*, or resigned to*
conventional reportage. It was certainly the case one morning while
gazing up at Notre Dame, but at least the weather (some showers!)
had given me something to work with. **I was looking for mood,**
toying with the idea of painting only part of the icon. *In*
short, playing with its recognisability. Just a flying buttress perhaps,
dwarfing a citizen on a park bench. But in contemplating the rain
puddles I wondered just how much distortion or inversion or cropping
an icon such as this could take without a loss of recognisability.

If it were reflected in near totality, would I need the source of
the reflection at all? Hopefully not, if the silhouettes of spires and
buttresses were used effectively. It was in fact one of the spires that
dictated the vertical format. Originally, pigeons were to be the
protagonists, but there were just so many sparrows there that day
bathing, that they begged to be included. I painted two small studies
and one medium size picture on site, and with the additional aid of
some photographic bird reference, produced what I believe is the most
compelling version – the birds at near life size and the pebbled
puddle in full transparent detail – later on back in the studio. **A lot**
of thought had gone into the final design and particularly
the placement of birds, including the need to subtly adjust
their isolation by knitting various branch reflections in
behind them.

Technically it was rather straightforward – big brushes, simple
colours – but heavy use was made of a water atomizer in order to
obtain the subtle detail required in both the sandy pebbled ground
and the rain-affected water surface.

An original take on a
familiar landmark. This
composition shows us
Notre Dame from a new
perspective that
intrigues and yet
domesticates its
grandeur.

A Congregation, Notre Dame, Paris
Watercolour on paper

Not everyone's vision of
New York, but a human
one. The Bowery has
gradually been throwing
off its seedy past,
emerging as a
characterful remnant of
old New York that retains
a powerful sense of
community.

Bowery II
Watercolour on paper

Sandra Walker

"

Bowery II

*My paintings are concerned mainly with man's inventiveness – a recording of the things man accomplishes in this world. While my buildings are factual, the geographical area alone is the constant – time and light and my manipulations for compositional purposes are the agents of change. The city constantly changes its appearance. **The ever-present wrecking ball often destroys existing forms while simultaneously revealing wondrous new ones.** This is the beauty of painting the city – nothing is fixed or fully predictable. Paint ages; bricks crumble; buildings change owners and appearance; **doors and windows open at chance angles to provide unexpectedly fine composition.***

My work has been influenced by the American painters Edward Hopper and Charles Sheeler, and also by the photography of Walker Evans.

Before becoming a full-time painter, Sandra Walker spent a decade working on Capitol Hill, Washington DC, first for Senator George McGovern, and then on the personal staff of Senator Edward M Kennedy of Massachusetts. Examples of her work are now held in the collections of both.

She moved to England in 1987 where she was commissioned by Margaret Thatcher to paint the Houses of Parliament. Awards include the Singer and Friedlander/Sunday Times prize for the Best British Watercolour, and the Grand Prix at the Tregastel Salon International de la Peinture a l'Eau in France. Her work has been exhibited worldwide and is held in many prestigious collections including the United States Mint, the Bank of America, New York, the Canadian Embassy, Washington DC, the American Embassy, Colombo, Sri Lanka, and the Wall Street Journal, New York. She is a Member of the Royal Institute of Painters in Watercolour.

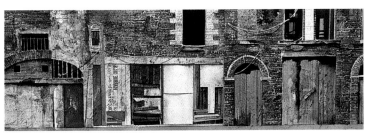

Liverpool Terraces
Watercolour on paper

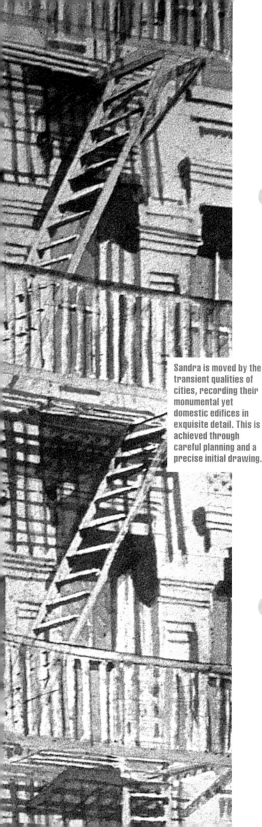

When most people think of New York, they are reminded of soaring skyscrapers, great parks, magnificent museums, and world-class places to eat. I, on the other hand, find myself drawn almost magnetically to the Bowery. Until the middle of the 20th century, the Bowery was known universally as 'Skid Row' – a neighbourhood of flop-houses, tattoo parlours, soup kitchens, and a collection of down-and-outers from all over America. Although there has been a significant reversal of fortune in the Bowery – most of the flop-houses and tattoo parlours are virtually a thing of the past – **there still lingers the vitality and sense of community depicted in my painting**. Above all, there is the marvellous architecture – those mellow brown bricks – with stories to tell; a perfectly preserved remnant of old New York.

Sandra is moved by the transient qualities of cities, recording their monumental yet domestic edifices in exquisite detail. This is achieved through careful planning and a precise initial drawing.

There are many approaches to painting, but of course, the matter is a subjective one. The one I have always preferred is a well-planned design in advance of the final work. I draw very carefully, with virtually nothing left to chance. Watercolour is an unforgiving medium – once that brushstroke is laid, there's not a lot you can do about it but start over. Therefore, **with my careful planning and this framework in place, the final painting may be as stark or as elaborate as my feelings of the moment dictate**. After making a detailed drawing I stretch my paper. I use quality 140lb. hot-press paper since I find it more accepting of the technique I use for ageing the bricks and stones, than rough or not surfaces. It also takes a lot of abuse.

I begin by trying mentally to establish the dominant colour mood which, in the case of 'Bowery II', is a sober one. My palette consists mainly of earth colours with Phthalo Blue, Payne's Grey and Lamp Black.

I start a painting at the point which interests me most. Here I decided to start with the dividing line which separates the two distinctly different sides of the building. Then I started adding some windows at random, until the overall pattern took form. I use a great deal of spattering, usually before I lay in my bricks. The spatter ultimately shows through the brick colours and adds to the texture. I continue to splatter during the addition of subsequent layers of paint on the bricks, and again when the bricks are finished. If I spatter in the same colour as the brick itself, it gives a grainy aged appearance and is an invaluable tool. I do this by tapping a loaded brush on the handle of another brush.

To complete the painting I just work over it in any order that comes instinctively. **Knowing when to stop is an important part of painting and one which does not come easily**. I sometimes get in a spattering mood and just go on and on – this can be disastrous. **Painting, for me at least, is a carefully planned, calculated sustained process which develops slowly and sometimes, but not always, reaches the desired end.**

*A sober palette
to suit the mood:
Earth Colours
Phthalo Blue
Payne's Grey
Lamp Black*

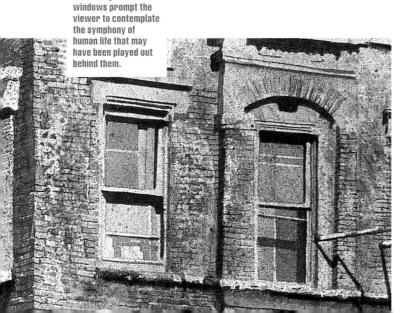

Beautifully rendered windows prompt the viewer to contemplate the symphony of human life that may have been played out behind them.

The atmosphere of anonymity and alienation that is evoked in Walker's works shown here, along with their suggestion of a time that is past, calls to mind her artistic influences. Edward Hopper was acutely aware of the sense of loneliness in the lives of American city dwellers in the interwar years, which he depicted with an almost eerie clarity. Charles Sheeler cut humanity out of his precisely rendered cityscapes altogether. Documentary photographer, Walker Evans, similarly produced precisely detailed images, predominantly of environments, but he also shot evocative scenes of the human experience of the Depression. Walker has continued the theme of the organic relationship between humanity and its urban environment.

The Guggenheim, Bilbao
Watercolour on paper

"Goodbye Roger Smith"
Watercolour on paper

> The paintings shown are of five different cities. At least three of these buildings no longer exist, but I hope my work has captured the spirit of these structures – their cleverness; their elegance; sometimes their daring (as in the Guggenheim), and once in a while, their pure poetry.

SANDRA WALKER'S TIPS ON TOOLS

I use a variety of tools to create a range of textures. On occasion I use razor blades, crayons, sandpaper, and expired credit cards, which I use for scraping out large areas. I also have some medical syringes which I find useful for spraying water patterns on decaying bricks. Winslow Homer claimed to have used day-old bread to blot out areas. I once had a Siamese cat who liked to take a nap on my still wet paintings. His fur left unique striations in the bricks – a wonderful effect which I've never been able to duplicate since he quite thoughtlessly died.

Never, ever use cheap paper, paints or brushes. All the foresight, planning and plain hard work can be completely undermined by using poor quality materials. It just isn't worth it.

SPATTERING FOR TEXTURAL EFFECT

Watercolour is an excellent medium for spattering and can be mixed to varying consistencies depending on the required effect. Walker spatters paint both under and over painted layers, building up a rich depth of texture and giving her old brick buildings real authenticity. Some artists prefer to use a toothbrush or a spray bottle, but tapping one brush on to another is effective and requires no extra planning!

Detail, **Howard Street, Baltimore**
Watercolour on paper

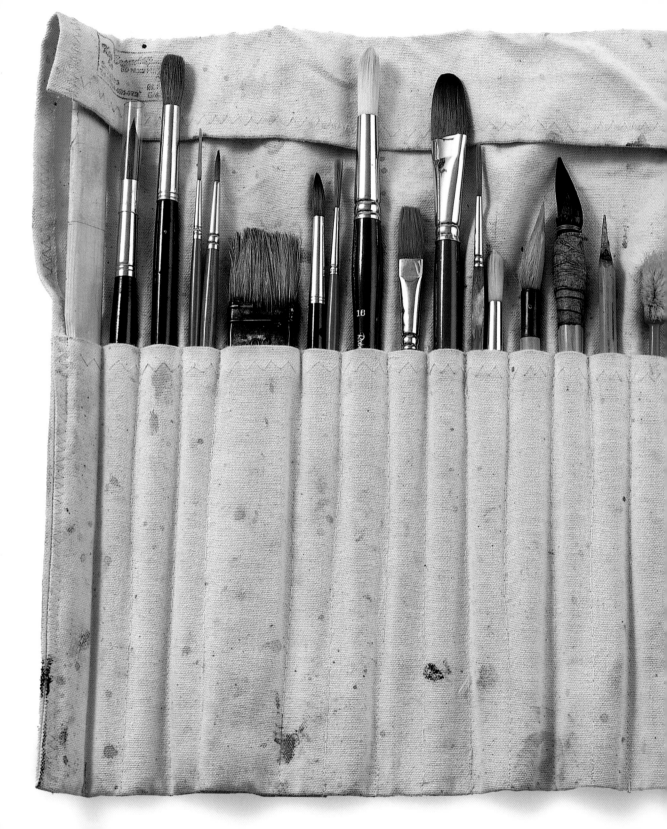

When working in the field it is important to travel light. The Travelling Studio (above), is a good solution. It contains everything that you will need – a sketch block, brushes, a small paint box and water, all neatly packed in a protective case.

Always take care of your brushes. It is so easy to damage the bristles. A lightweight brush roll (left), keeps them dry and protects their heads well. It also makes their selection a great deal easier.

Many artists use colour instinctively, but this is usually based on years of experience and a thorough understanding of colour theory and mixing. The essentials are not difficult to understand.

the colour wheel

The colour wheel is the artist's basic, and perhaps most important tool. It consists of the principal colours of the spectrum, pulled round into a circle. Each of the three primary colours, (red, yellow and blue), are separated by the secondary colours (orange, green and purple). Such an arrangement allows the artist or designer to see the relationships between colours and see how they will work with one another.

primary colours

A primary colour (red, yellow or blue) is a colour that cannot be made by mixing other colours.

secondary colours

A secondary colour (orange, green or purple) is made by mixing two of the three primaries.

tertiary colours

Tertiary colours are produced by mixing two colours that are next to each other on the colour wheel, e.g. red and orange to produce a red-orange, or yellow and green to produce a yellow-green.

complementary colours

Complementary colours lie opposite each other on the colour wheel and, if placed together, create the most vibrant and discordant contrast: red-green; blue-orange; yellow-purple. When complementary colours are mixed together they create neutral greys and browns.

In theory, any colour imaginable can be mixed from the three primaries, but in practice, you will find that you still need to purchase other colours. This is due to the fact that paint pigments are not 'pure' and each variant of a colour will have a different colour temperature.

colour temperature

We don't need to know about colour theory to have a basic understanding of colour temperature. All of us already have associations through life experience. Reds and oranges remind us of fire or sunshine, and suggest warmth. Blues are cool colours, associated with water. We also make more subtle judgments such as recognising that some people have cool skin tones, whilst others have warm. It is this subtlety that is important to understand in colour mixing. A harmonic colour scheme tends to present itself naturally, for example in a sunset where all the colours tend to be warm, or in an early morning winter scene where blue tints are dominant. However, in paintings with a more varied colour scheme we need to be aware of the fact that warm colours will come forward in a composition, whereas cool colours will recede. If this is not properly handled, the composition will fall apart.

All types of paint are made up of pigment and a binder, along with a vehicle, which allows it to flow and mix. Watercolour consists of finely ground pigment bound with gum arabic. Additional constituents include glycerine, which makes the paint more flexible, and a wetting agent, usually ox-gall, which improves the flow of the paint on the paper. Watercolour, as the name implies, is then diluted with water for use. It is available in either pans or tubes, and in artists' or students' quality.

pans and half pans

Pans and half pans are little blocks of colour made to fit into the compartments of metal watercolour boxes. These boxes can be bought with a standard selection of colours, but it is preferable to buy an empty case and fill it with the colours you really want to use. This type of watercolour is particularly good for painting outdoors since it is so portable, immediately ready for use, and performs well for smaller paintings.

watercolour in tubes

The collapsible metal tube was invented by John Goffe Rand in 1841 and by 1849 was being used for watercolours. Tube paints give more brilliant results and have the capacity to work well on larger paintings. They also have the advantage of remaining clean whilst pans can quite easily get messed up with a dirty brush or cavalier mixing.

artists' paints

Artists' colours are superior quality paints containing a high proportion of pure, permanent and finely ground pigment. They produce excellent results, giving luminous, clear colours and mix well. There is a huge range of colours available, but the prices vary depending on the pigment involved.

student-quality paints

The pigments in student quality paints are not as pure as the artists' variety, and contain more fillers and extenders. As a result they are considerably cheaper. The colour range is also more limited than that available in artists' quality.

transparent pigments

Transparent pigments are those colours that are highly transparent and allow the white of the paper to show through. They are particularly useful when one wants to capture atmosphere and light.

opaque pigments

Opaque pigments are actually transparent when well diluted, but if they are mixed with other pigments they produce an opaque effect. Care is needed when using them otherwise a painting can become dulled.

body colour

If transparent watercolours are mixed with Chinese white or gouache, they become opaque. In this state they are known as body colour. Purist watercolour artists will simply dilute their colours to make them lighter, and leave areas of the paper white to achieve their highlights. Body colour can, however, be used very effectively for this purpose.

egg tempera

Tempera is a very old medium made by mixing egg yolk with pigments and distilled water. It is a very durable medium that can produce a beautiful, clean finish. It demands a very painstaking method of preparation and application, although there are now a few manufacturers who supply a limited range of ready prepared paint.

distilled water

Some artists prefer to use distilled water to dilute their watercolours since it can reduce granulation. Other artists positively enjoy the texture granulation creates, and even add a granulation medium to their paints to encourage this.

watercolour mediums

The balance of the constituents of watercolour (see opposite) can be proportionally changed to affect the working properties of the paint. Such additives are called, rather confusingly, 'mediums'. The addition of extra gum arabic increases the glossiness and transparency of watercolour which can give a kick to the colours and texture. The addition of glycerine helps the artist working in dry and warm conditions since it makes the paint more flexible, preventing it from drying too quickly. Ox-gall improves the fluidity of the paint, and enhances its performance when used wet-in-wet.

other water-based media

gouache

Gouache is an opaque watercolour. It is possible to use it very much like traditional watercolour, but it is more generally used when solid, intense and pure colours are needed, principally in the area of graphic design. Lower quality gouache can contain white fillers which gives it a rather chalky matt finish.

acrylic

Acrylic is a relatively new painting medium, introduced in the 1950s. Many artists find acrylic paint a wonderfully flexible medium that can achieve both the transparency of watercolour and the rich and potentially textural quality of oil, all with the advantage of being diluted and cleaned up with water. As the paint dries (which it does rapidly), the acrylic-resin particles fuse to form a flexible and waterproof film.

type and size of paper. Thicker or heavyweight papers are those that are over 300gsm/140lb. These don't need to be stretched since they will take a lot of water before cockling. Lighter weight papers do need to be stretched on a board before painting begins, unless they are supplied in a watercolour block. These are pads of paper glued round the edges and mounted on a backing board. When the painting is complete, the sheet needs to be removed with a palette knife.

stretching paper

Lighter weight papers will wrinkle and cockle if they are not stretched prior to painting. To do this you need a board slightly larger than your paper, and thick enough not to warp. The paper needs to be totally wetted by immersing it in water for a few minutes to ensure water has been absorbed on both sides. After removing it and gently shaking it to get rid of any excess water, it should be placed carefully on the board, and smoothed out from the centre. A dry sponge can be used to ease out any bubbles and to remove further moisture, particularly from the edges. You will then need strips of gummed brown-paper tape (gum-strip), cut a couple of inches longer than the paper sides. Apply this to the paper after wetting it, starting with the longest sides, and ensuring that the tape sits equally over the paper and board. The paper should then be allowed to dry flat, naturally, to prevent splitting. The painting should not be cut from the board until the last brushstroke has dried.

Papers from top to bottom:
Hot-pressed
Cold-pressed
Rough

papers

hot-pressed paper

Hot-pressed paper is more heavily sized than other papers. It has a very smooth surface which is suitable for detailed work. However, it is less popular than cold-pressed and rough papers for watercolour painting, since the slippery surface can repel paint, making it difficult to control and causing it to settle in puddles.

cold-pressed or not paper

Cold-pressed paper is the most popular of all watercolour papers. It has a semi-rough surface and is sometimes referred to as 'Not' to state that it is not hot-pressed. The texture holds the paint well, and takes smooth washes, yet it is not so rough as to prevent detailed brushwork.

rough paper

Rough paper has a very pronounced texture so that when a wash is laid, some of the paint can settle in the hollows, whilst in other places it skims over, leaving the paper white. This lends a sparkle to the painting, but makes it less suitable for highly detailed work.

paper weight

The weight of a paper is given in two ways. One is the weight of a sheet of paper in grams per square metre (gsm); the other describes the weight in pounds of a ream (500 sheets) of that particular

paintbrushes

You only need a few brushes to paint well in watercolour as long as they are the right shape and size for the particular effect you want. Generally a couple of small brushes, a middle-sized and a large one, should suffice. Every artist will tell you to buy the best brushes you can afford. The best brushes are made from sable, the most expensive being taken from the tail of the Kolinsky sable, found in Northern Siberia. However, with growing concern for the rights of animals, synthetic substitutes are becoming increasingly popular. What is important is that it should hold its shape and point. It should be capable of holding a good quantity of paint, with a springy, responsive feel.

Brushes from top to bottom:
Spotter
Rigger
Round
Filbert
Flat
Oriental
Mop
Bright
Fan blender
Swordliner
Rigger

SERIES 16 · ARTISTS' SABLE · WINSOR & NEWTON · ENGLAND

"PREMIER" P37A red sable GERMANY

"PREMIER" P 27EX PURE SABLE GERMANY

PREMIER P340 red sable W.Germany

Dalon D88 DALER-ROWNEY U.K

50609482

From left to right:
Flat wash
Graded wash
Variegated wash

techniques

washes

The painting of a wash is the key technique of watercolour painting. Washes are thin layers of transparent or heavily diluted paint, and can be flat, graded or variegated.

A flat wash is an even, thin layer of paint used to tint bare paper. Further washes can then be overlaid to build up the colour.

Graded washes work from a more saturated hue through to a highly diluted, thin colour.

Variegated washes include two or more colours which blend together naturally on the paper as they are loosely applied.

wet-in-wet

Painting wet-in-wet is the best technique to use to create soft edges and blended colours. You can either dampen the paper first with clean water before dropping in the colour, or add colour to an area of paint that is still wet. In both cases the paint will run, creating loose, softly blended colours and shapes.

wet-on-dry

More controllable than painting wet-in-wet, is painting wet-on-dry. Here paint is applied to dry paper, or to areas that have already been painted but which are thoroughly dry. Crisper edges result and interesting colour effects can be created as transparent layers build up.

special effects

An unusual textural effect can be achieved by dropping salt crystals on to wet watercolour. The salt absorbs the moisture, causing the colour to form little circles. Some artists experiment with cling film, laying it over damp paint, and then waiting for it to dry before removing the film. Lines are created where the film has formed wrinkles. Perhaps more controllable is the application of wax which then resists any further adherence of paint. In this way highlights can be reserved, or a variety of textural effects created.

From left to right:
Wet-in-wet: wet paint dropped on to wet paper
Wet-in-wet: wet paint on wet paint
Wet-on-dry: wet paint on dry paint

From left to right:
Cling film
Salt crystals
Glaze

aerial perspective

We use the term aerial (or atmospheric) perspective to describe the means of creating an illusion of depth by imitating the effects of the atmosphere which make objects look bluer and paler the further they are from the viewer. Leonardo coined the term, although artists at Pompeii had already been using the technique. Leonardo, keen to measure and provide rules, wrote, 'if one is to be five times as distant, make it five times bluer'.

backrun/bloom

Backruns or blooms usually happen by accident, and can be a beginner's nightmare. However, they can be used consciously for interesting effects. They occur when a wet wash hits another, slightly drier, wash.

cockling

This is the wrinkled effect that occurs when washes are applied to thin paper or that which has not been stretched.

contre-jour

Literally in French, this means against the light, or daylight. In practice it's the term used for paintings where the light source is behind the subject.

flocculation/granulation

The grainy texture produced by some pigments where the pigment particles settle in groups rather than completely dissolving.

glaze

A transparent or semi-transparent wash laid over another, different colour wash to produce luminous, new colours.

masking fluid

Masking fluid can be a wonderfully useful medium. It's a rubbery type of liquid which will resist any overlays of watercolour once it's dry. It can, therefore, be painted over freely, whilst highlights are preserved under its cover. When the painting is thoroughly dry, the masking fluid can be simply rubbed off. Don't apply it with your best brushes, though – it will ruin them!

painting en plein air

Painting outdoors, literally 'in the fresh air', direct from 'life'.

From left to right:
Backrun/bloom on flat paper
Backrun/bloom on tilted paper
Flocculation

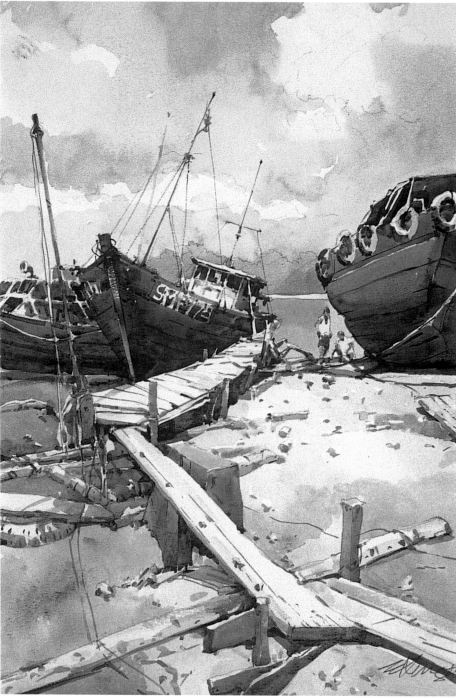

Ong Kim Seng wanted his focus to be the two idle boats waiting for repair. The Iron Oxide Red of the weathered boats was carefully chosen so that they would stand out. The eye is led around the painting through the inclusion of the footpath, the jetty, and the positioning of the clouds which form a 'V' shape with the sharp end at the point of interest – the smaller boat.

Boats at Rest
Ong Kim Seng

Greg Allen
address: 2a Ernest Street,
Blackburn 3130, Victoria, Australia
telephone and fax: +61 39 890 3410
email: artistgregallen@bigpond.com

David Bellamy
address: Maesmawr, Aberedw,
Builth Wells, Powys, Wales, LD2 3UL, UK
telephone: +44 (0) 1982 560237
email: DAJbellamy@cs.com
website: www.DavidBellamy.co.uk

Carol Carter
address: 4450 Laclede Avenue, St. Louis,
Missouri 63108, USA
telephone: +1 314 531 8311
email: carolc@carol-carter.com
website: www.carol-carter.com

Sally Cataldo
address: 2126 Contra Costa Avenue,
Santa Rosa, California 95405, USA
telephone: +1 797 526 3908
email: sally@svn.net
website: www.sallycataldo.com

Trevor Chamberlain
address: Braeside, Goldings Lane,
Waterford, Hertfordshire, SG14 2PT, UK
telephone: +44 (0) 1992 586195

Alwyn Crawshaw
address: The Hollies, Stubb Road, Hickling,
Norwich, Norfolk, NR12 0YS, UK
telephone: +44 (0) 1692 598812
fax: +44 (0) 1692 598906

June Crawshaw
address: The Hollies, Stubb Road, Hickling,
Norwich, Norfolk, NR12 0YS, UK
telephone: +44 (0) 1692 598812
fax: +44 (0) 1692 598906

David Curtis
address: Gibdyke House, Gibdyke, Misson,
Doncaster, S. Yorkshire, DN10 6EL, UK
telephone and fax: +44 (0) 1302 719624

Rob Fairley
address: Alisary, Loch Ailort,
Fort William, Scotland, PH38 4LZ, UK
telephone and fax: +44 (0) 1687 470243
email: robfairley
@alisary.freeserve.co.uk

Michael Felmingham
address: 202 Rugby Road, Royal
Leamington Spa, Warwickshire,
CV32 6EH, UK
telephone: +44 (0) 1926 332724

Louis Gadal
address: 3648 Coolidge Avenue,
Los Angeles, California 90066, USA
telephone: +1 310 397 2743
email: lgadal@ucla.edu
website: www.seadragon.com/gadal

Peter Graham
address: Flat 1, The Knowe, 301 Albert
Drive, Pollokshields, Glasgow,
Scotland G41 5RP, UK
telephone and fax:
+44 (0) 141 423 5081
email: pg.roi@virgin.net

Brian Lancaster
address: Galloway, Waterley Bottom,
North Nibley, Gloucestershire,
GL11 6EF, UK
telephone: +44 (0) 1453 546901

Jann Pollard
address: 105 La Mesa Drive, Burlingame,
California 94010, USA
telephone: +1 650 342 8891
fax: +1 650 347 3959
email: pollardart@aol.com
website: www.jannpollard.com

Vivienne Pooley
address: Hyninglea Studio, Low Biggins,
Kirkby Londsdale, Lancashire,
LA6 2DH, UK
Further examples of her work at:
website: www.gatleygallery.co.uk

Alan Reed
address: 17 Cheviot View, Ponteland,
Newcastle upon Tyne, NE20 9BP, UK
His gallery is at The Eldon Garden
Shopping Centre, Percy Street,
Newcastle upon Tyne, UK
telephone: +44 (0) 1661 820626
email: sales@alanreed.com
website: www.alanreed.com

Cecil Rice
address: 14 Granville Road, Hove,
East Sussex, BN3 1TG, UK
A selection of Cecil Rice's prints are
available from Obsession Publishing
telephone: +44 (0) 1273 710287
email: rice942000@yahoo.co.uk
website: www.cecilrice.com

Jacqueline Rizvi
address: 24 Sunny Gardens Road, Hendon,
London, NW4 1RX, UK
telephone: +44 (0) 20 8457 9653
email: jlrizvi46@hotmail.com

Michael Schlicting
address: 3465 NE Davis Street, Portland,
Oregon 97232, USA
telephone and fax: +1 503 235 6978
email: michael@michaelschlicting.com
website: www.michaelschlicting.com

Ong Kim Seng
email: kseng@pacific.net.sg

Bob Wade
Bob Wade's paintings are reproduced
by arrangement with International
Artist Magazine.
address: 524 Burke Road, Camberwell,
Victoria 3124, Australia
telephone: +61 39 813 1154
fax: +61 39 882 6604
email: rawade@ozemail.com.au

Sandra Walker
address: 39 Stewkley Road, Wing,
Leighton Buzzard, Bedfordshire,
LU7 0NJ, UK
telephone: +44 (0) 1296 681009

Lian Zhen
address: Zhen Studio, PO Box 1060,
Pinole, California 94564, USA
email: lianzhen@yahoo.com
website: www.zhenstudio.com

There are many people I would like to thank who have contributed to the production of this book. I am most grateful to Brian Morris, of AVA Publishing, and my editor, Kate Stephens, who gave me the opportunity and guidance to undertake such an interesting project. I am beholdent also to Sally Chapman-Walker for her impressive and sympathetic design work that allows the paintings to sing. Without her experience and assistance I would have been totally lost! Robin Wiggins expertly provided the various paint effects and palettes, and kindly allowed us to delve into and discover the tools of his trade, whilst Julien Busselle skillfully photographed them. I am very grateful to them both.

Many thanks are due to my parents for playing their role as grandparents to Oscar level. My children would have starved and probably divorced me were it not for their benevolent presence. Finally, thanks must, of course, go to all of the artists who contributed work with such generosity and kindness. They have made the writing of the book such a pleasure, and supplied me with a whole new set of friends.

Theodora Philcox